Flower Painting in Watercolor

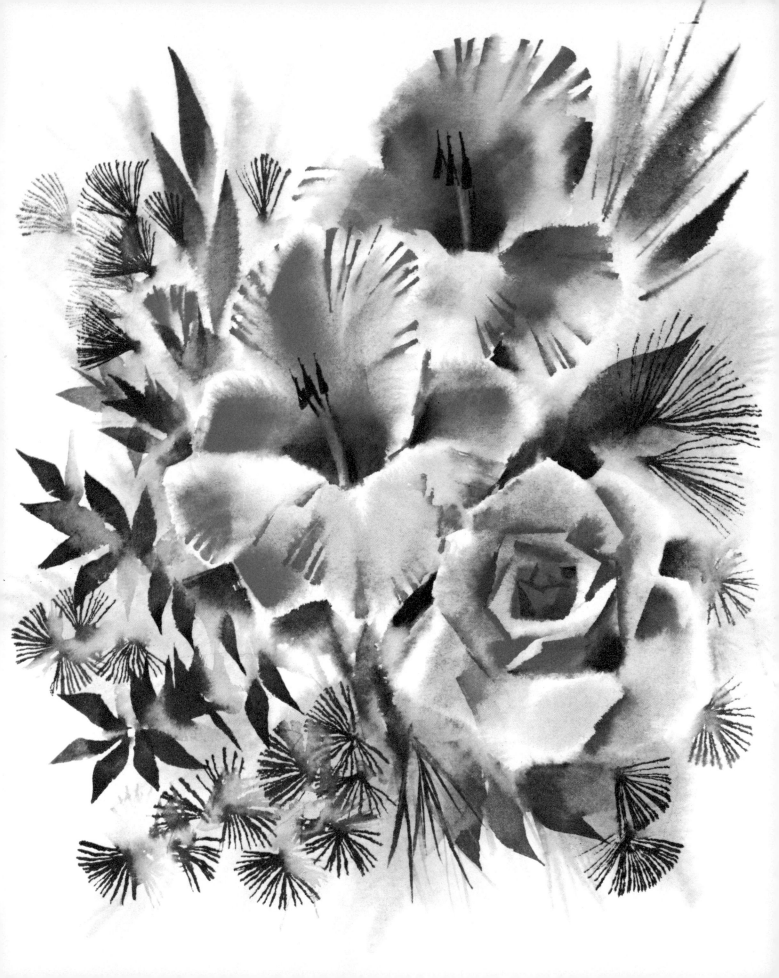

Flower Painting in Watercolor

Mario Cooper, N.A.

 Reinhold Publishing Corporation • New York

© 1962, REINHOLD PUBLISHING CORPORATION
SECOND PRINTING, 1966
ALL RIGHTS RESERVED
PRINTED IN THE UNITED STATES OF AMERICA
LIBRARY OF CONGRESS CATALOG CARD NO. 62-10718

DESIGNED BY MYRON HALL, III
PRINTED BY THE COMET PRESS, INC.
BOUND BY PUBLISHERS BOOK BINDERY

To

Aileen

Vincent

Patricia

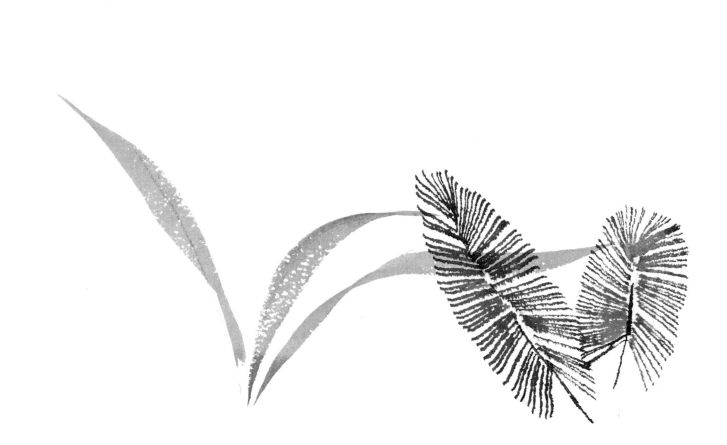

My thanks to Gloria Dale Meyers for her assistance in preparing the manuscript.

Contents

Introduction

One day in the summer of 1960 I happened to run across a few flower paintings in a little gallery in Manhasset, Long Island. I had never seen the water color brush used in such a brilliant manner, at least in flower paintings. They excited me so much that I telephoned Mario Cooper that evening to ask if he would consider preparing a manuscript on his unusual painting methods for Reinhold Publishing Corporation, where I was then consultant for art books.

Cooper's quick response was inspired by the opportunity for him to share with a reading audience a unique painting system which he has developed as a practicing artist and as a teacher at New York's Art Students League. The method is an original one based upon an ancient painting tradition, Sumi-e, inherited from the Japanese; it exploits the versatile short hair, square brush. To this approach the author applies a system of teaching communication based upon the face of the clock and the direction of its hands to indicate the position and movement of the brush.

The remarkably facile and expressive brush technique of the Japanese realizes fully the resources and aptitudes of a tool for a particular task. They recognize the "instinct" of a tool, which *leads* as well as *submits* to the artist's purpose. Thus, in this book, Cooper has set forth his methods in an easy-to-follow series of brush demonstrations showing the strikingly beautiful effects that can be achieved by using the chisel-like edge of the square brush to paint a great variety of naturalistic leaves and flowers in single and multiple strokes. When the reader correlates the diagrammatic instruction with the author's illustrative paintings, he has a complete exposition of method and result. Cooper analyzes the structure of leaves and flowers in terms of their basic geometric forms and relates this analysis to the action of the square brush in rendering their details.

Discussions of paper, paints, and other technical involvements of watercolor painting are, of course, treated in detail. Both dry and "in wet" methods are discussed with demonstrations in color of their functions and their correlation in producing unusual effects. In short, this book is as delightful as it is most revealing. It will appeal to both elementary and advanced students: to beginners because of its simple and logical instruction, to professionals because of a fresh point of view that will surprise many experienced painters. While the focus is on flower painting, what Cooper teaches of brush technique, color, and the behavior of the watercolor medium under different conditions will be stimulating and useful to the painter of almost any subject matter.

Flower painting is but an incident in Mario Cooper's art career. His creative drive has brought him prominence in three fields—illustration, sculpture, and painting, all overlapping, to be sure, yet each usually implying a separate goal. In each of these he is known as a man of conspicuous talent, confirmed by honors and prizes and the demand for leadership in various art societies.

ERNEST W. WATSON

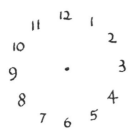

Communication

One windy day while I was taking my little girl to the bus terminal, a cinder blew into her eye. Although I could see it, I was unable to remove it. I took her to the nearest drugstore, but the druggist was unable to locate the tiny speck. So I said, "It's at seven o'clock." In an instant he had it.

The face of the clock "speaks" in a universal language. It is the clearest and most efficient means of teaching the brush-stroke technique used in the method of flower painting demonstrated in this book.

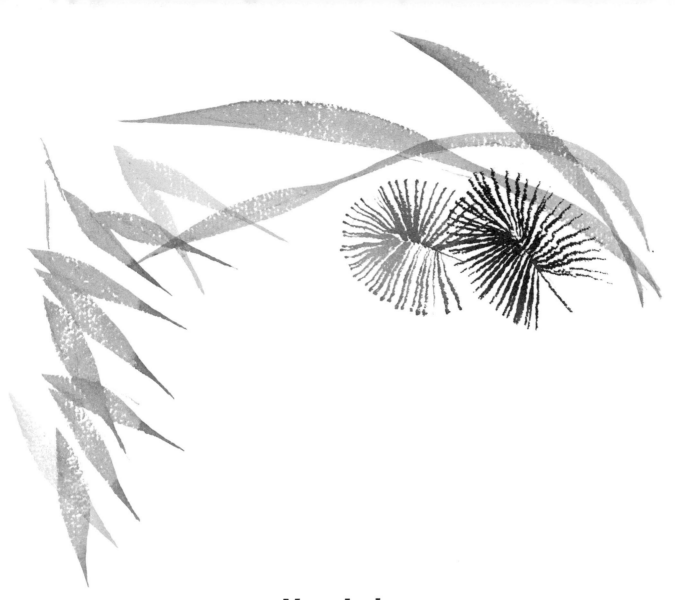

Vocabulary

The demonstrations of flower painting on the following pages are identical to those I use in personal classroom instruction. Everyone at all familiar with oriental painting will, of course, recognize its influence on the brush technique employed here. To my knowledge, no work has been published in our country that has successfully dealt with the "vocabulary of the brush" which for centuries has been the basis of Eastern art. Its simplicity and calligraphic beauty are universally ad-

mired. Learning to use this method has been a source of such pleasure to me that it is a privilege to share it with Western artists. Although we cannot undertake to explore the philosophy of the Tao methods — what the Chinese call "the Way" — there is much to be gained in applying to our own way these fascinating and readily learned methods of using the brush. On the following two pages the contrasting effects of this method are demonstrated on dry paper and on wet paper.

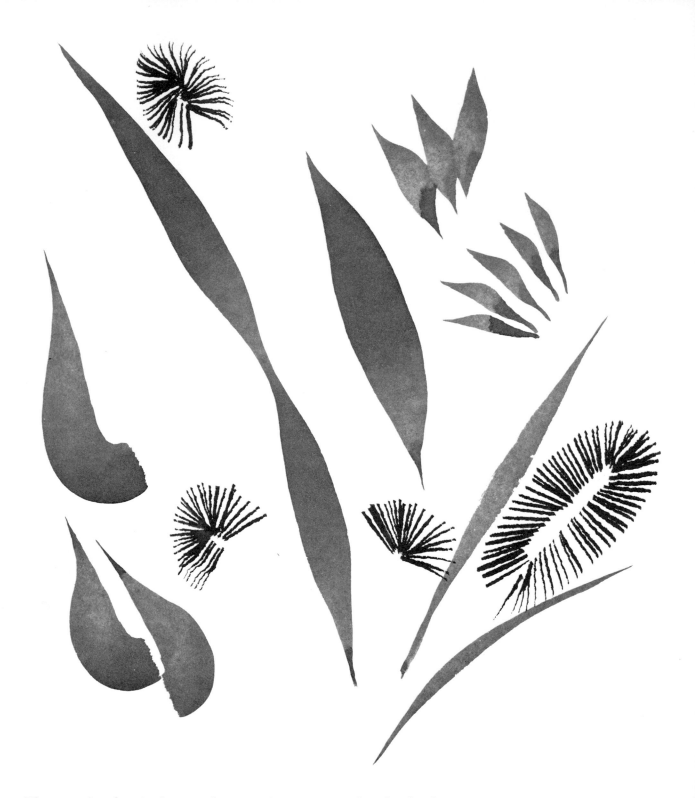

The completed painting on the opposite page, rendered in the in wet method, was made with the basic strokes demonstrated in the leaf forms above, done on dry paper. In the finished painting, the leaves with diffused edges in the background were painted while the paper was quite wet. The other leaves, as can be seen by the relative sharpness of their edges, were added as the paper dried. The most sharply defined leaves were put in when

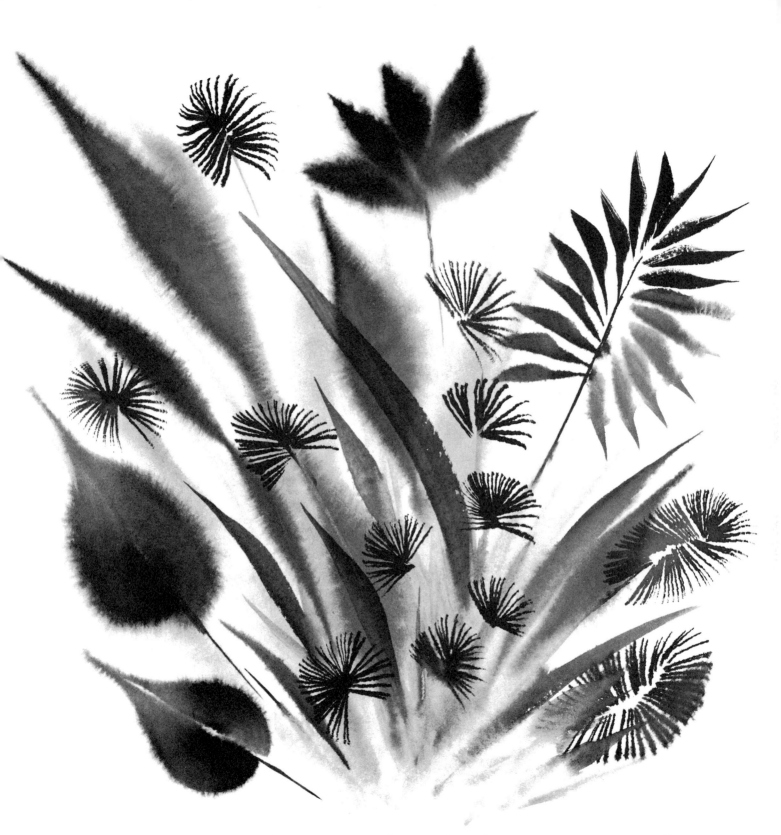

the paper was virtually dry. (The in wet method is fully described in a later chapter.) Pages 14 and 15 show diffused leaf forms begun when the paper was wet as well as sharper forms that were added after the paper had dried.

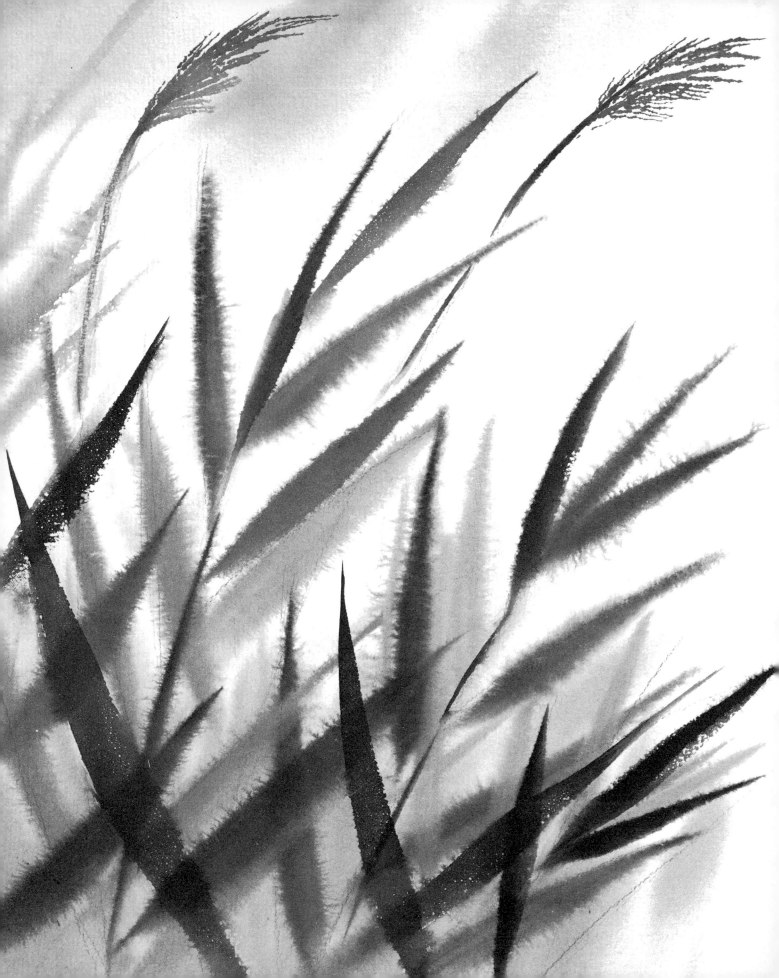

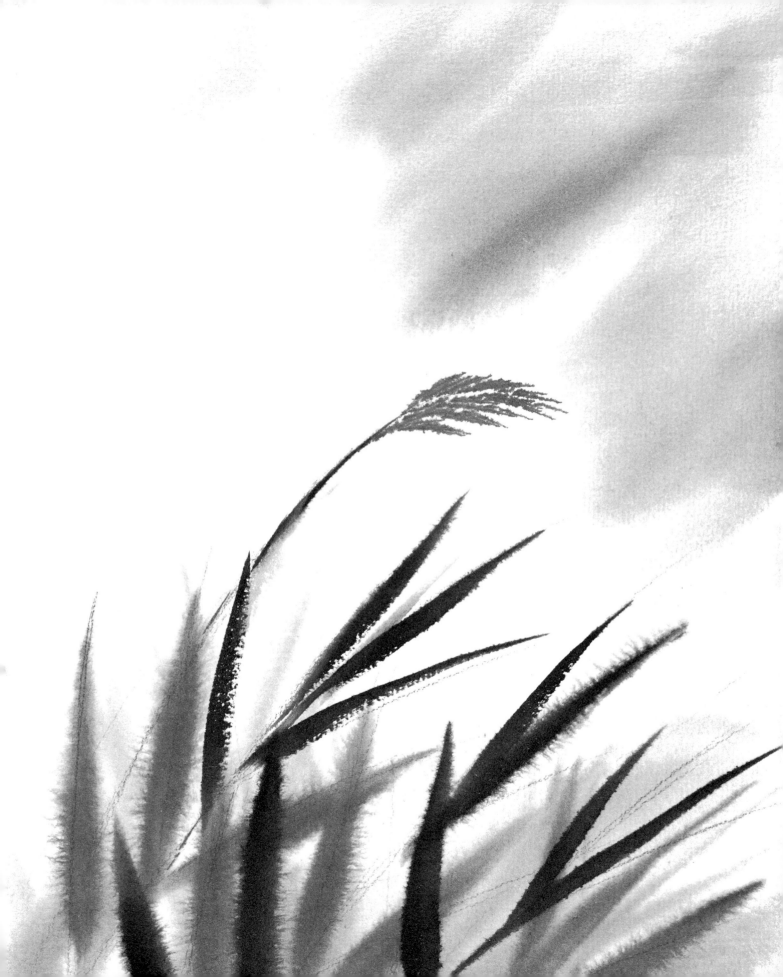

Analysis of Form

On preceding pages you have seen some flower painting effects and noted the brush strokes used to make them. Now we should begin to think of the designs of flower forms in terms of simple geometric shapes. Are they basically round in character, or are they related to the triangle or the square?

Design is the foundation of all good painting. Seldom does nature present the artist with meaningful design. What we call design is a creation of the human imagination. Apply this man-made sense of order to nature and the result can be a satisfying work of art— far more exciting than an unquestioning copy or a photograph could ever be. So after making a preliminary geometric analysis of the shapes of the flowers and leaves that we are going to paint, we will be ready to see how the brush can be handled to create patterns expressive of simple geometric shapes.

A glance at the design concepts of the orientals makes us aware of their symbolizing approach to everything they did. To the ancient Japanese three basic geometric shapes contained mystical meanings: the triangle symbolized Heaven, the circle Man, and the square Earth. These symbols were constant in all their graphic expressions. The principle of conflict of opposites was expressed in oriental philosophy and art by Yin, the negative or feminine principle, and Yang, the positive or masculine principle. In addition, when the Chinese and Japanese make a dot, they give it a recognizable form. If more than one dot is used, they usually are different and can be identified by their shapes as "ox head," "eagle's beak," "turtle head," or "tiger's claw." The brush strokes can also be identified by name, such as "carp," "wasp's body," "nails," "rat's tail," etc. The Chinese call the direction of a stroke the "bone," the thickness the "flesh," and the water which governs the intensity the "blood."

These symbols do not, of course, enter into our occidental painting philosophy, but they are of interest to the modern watercolor painter both in demonstrating the deep involvement with which the Orient approached even the simplest graphic expression and in providing a basis for variety and unity in organization and design that is essential to all good art, whatever its sources.

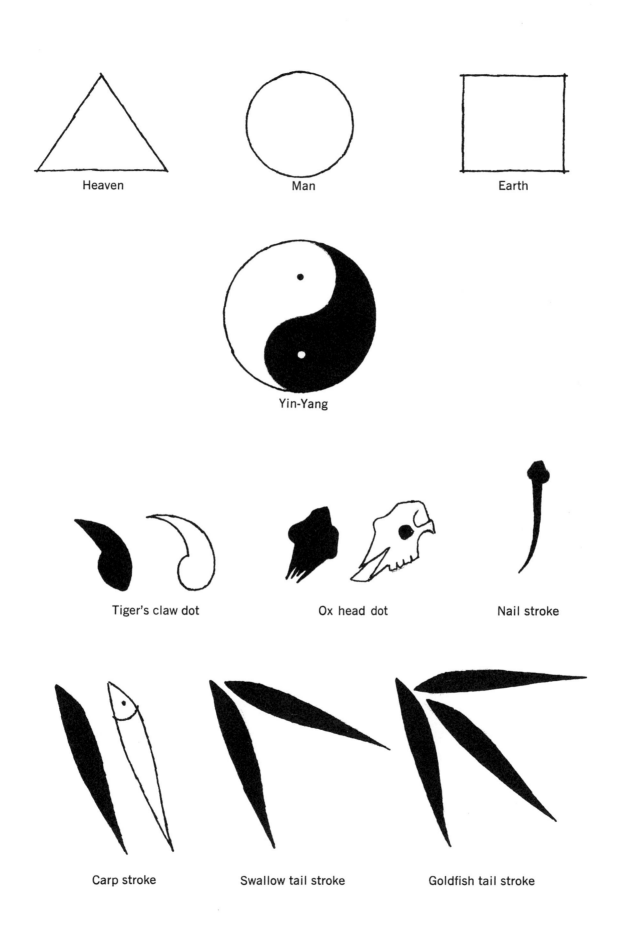

Heaven

Man

Earth

Yin-Yang

Tiger's claw dot

Ox head dot

Nail stroke

Carp stroke

Swallow tail stroke

Goldfish tail stroke

Bird of Paradise. Diagrammatic analysis showing the basic geometric shapes — circle, triangle, and square — used in the painting shown on the facing page.

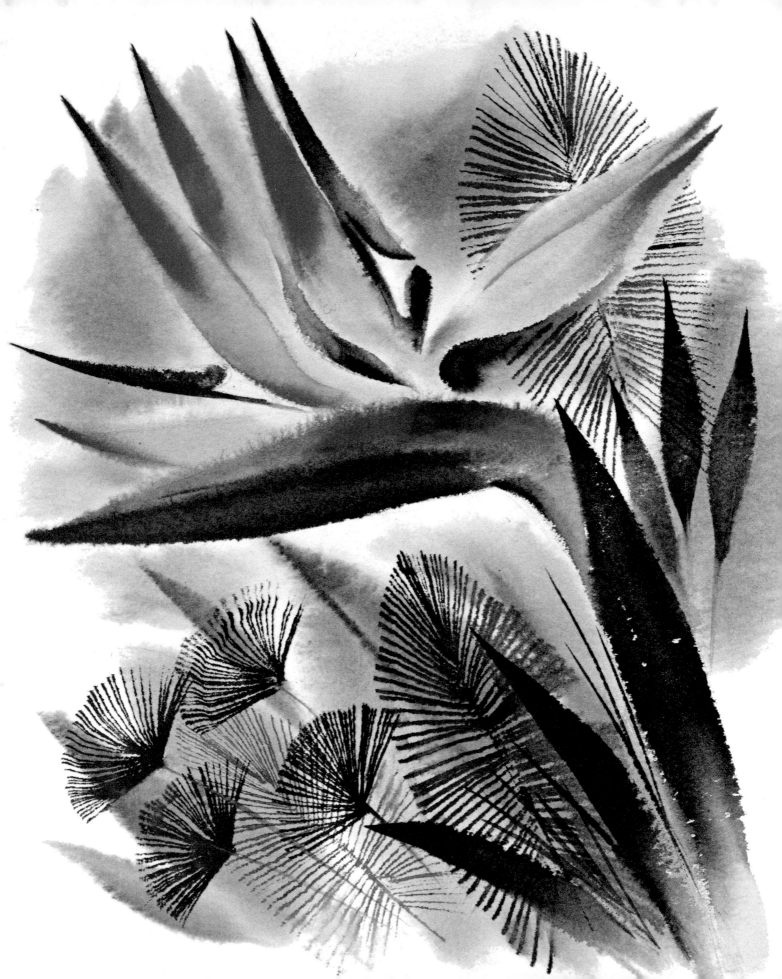

Let's Practice

We cannot overemphasize the basic geometric shapes of objects—especially when drawing and painting flowers and leaves. For our purposes we will consider the triangle, the square, and the circle as the geometric bases for all of our lines and shapes. Now, if we remove the base from the triangle and the square and take away one half of the circle, the resultant forms, in varied scales and combinations, can create an almost limitless number of shapes.

Triangle

Square

Circle

Multiple
triangles

Multiple
squares

Multiple
circles

Triangle
plus circle

Square
plus circle

Triangle plus
square, plus circle

LEAVES

We will begin by applying combinations of these shapes to leaves. Leaves are generally flat, so we need not be too concerned at this point with volume or three dimensions. That will be discussed later. Our problem now is to learn to use these simple elements, singly and in combination, to create basic leaf forms such as those shown above.

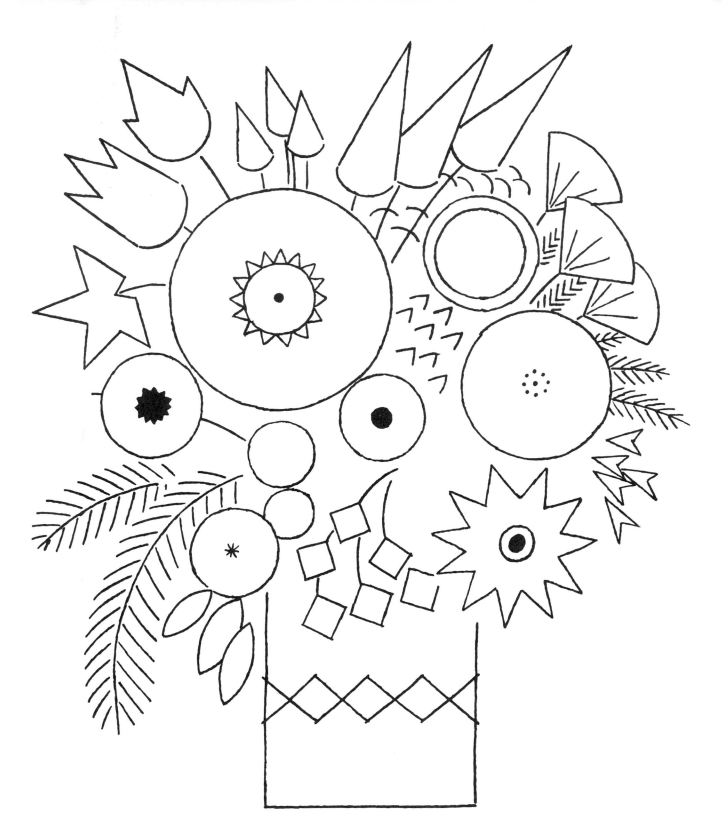

This decorative composition of leaves and flowers was produced by using various combinations of the triangle, square, and circle.

VENEER HIDES THE BASIC FORM

When painting objects, remember that surface texture often hides the basic inner form. For example, a sawtooth (based on the triangle) can enclose a basically circular form, or a scalloped edge (based on the circle) can hide a triangular form. Try first to determine the underlying shape and *then* the surface texture.

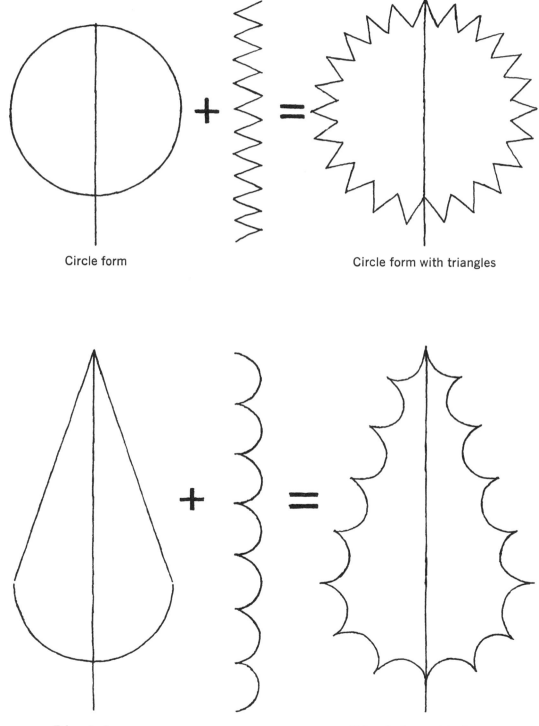

Circle form Circle form with triangles

Triangle form Triangle form with circles

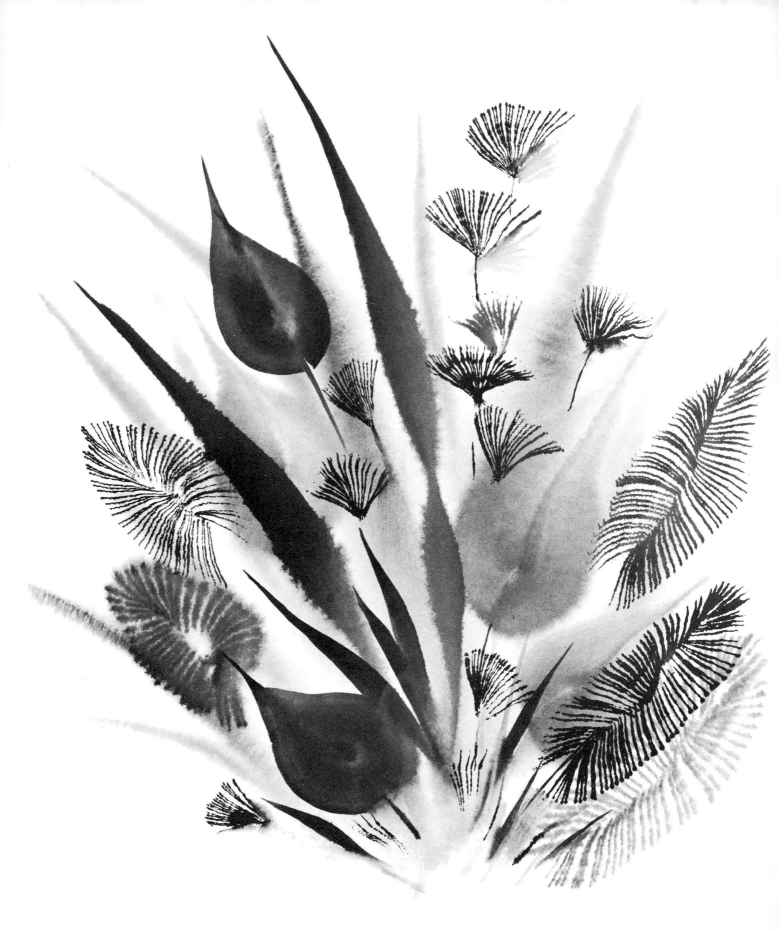

Materials

PAPER

There are many kinds of watercolor paper available. They vary widely as to size, form, weight, and surface texture. The best paper is handmade and comes in a variety of weights. The weight of paper is important, as a paper that is too light will wrinkle. The thinnest type in common use weighs 72 pounds (per quire); a medium weight is 90 pounds, and a medium-heavy paper is 140 pounds. Papers from 250 to 400 pounds come in board-like sheets and will withstand fairly rough treatment.

Most watercolorists prefer paper with a rough surface, but smooth types are available. Whatever surface and weight you choose, be sure to look for the manufacturer's mark, which is located in the lower righthand corner of the side to be used. Some papers are finished on one side only, the reverse having blemishes; while others are finished on both sides and can be used on either.

For our purposes, paper which comes in blocks is the easiest to use. The blocks, which are made up of many sheets of papers, are glued together all around the edges, which permits the top sheet to straighten out flat upon drying. You may also use single sheets of paper. These, however, must first be stretched on a board in the following way:

Wet the paper on the side upon which you are going to work; when the paper curves convexly, gently flatten it out on a piece of three-ply board large enough to allow for a two- or three-inch margin around the paper. Now, staple the paper along its edges to the board, working from the center of the edges upward and downward to the corners. When the paper dries, it will be stretched taut and you will be ready to work.

Two papers which I have found highly successful are D'Arches and Whatman. The former is an excellent French paper, with a slightly warm tint, available both in blocks of about 20 small sheets and in single sheets. Whatman, an English paper, is similar in quality to D'Arches, but it is whiter. For most sketching and general practice I have found the blocks manufactured by Morilla quite suitable. I would suggest that you use these or some other similar quality in the beginning.

Here are the names of some standard size sheets in use today:

Royal—19 x 24
Super-royal—14½ x 27
Imperial—22 x 30
Elephant—23 x 28
Double elephant—26½ x 40
Antiquarian—31 x 53

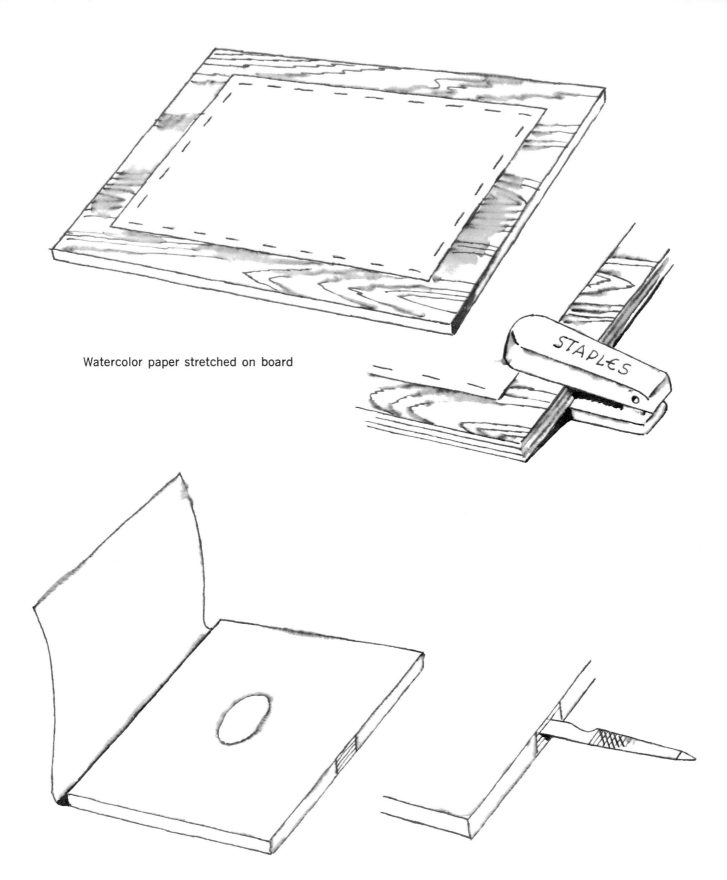

Watercolor paper stretched on board

Section of block paper with slot for inserting a file or knife to aid in the removal of each sheet as used

STAPLES

PAINTS AND BRUSHES

The painting methods we will explore in this book are best accomplished with square brushes. To some of you this will come as a surprise. However, once you become accustomed to square brushes, you will be delighted with their versatility and their low cost, about one-fourth the price of round brushes. I prefer the short-hair brushes (known as "brights") and recommend sizes 20, 18, 16, and 14. Always insist on the best sable, which can be identified by the little "belly" formed by the hairs.

When selecting your brushes at the art supply store, be sure to test them first. Ask for a small cup of water into which you can shake the brush thoroughly to remove any adhesive the hairs may contain. Then, snap the brush with a quick flip of the wrist. The hairs should form a fine, chisel edge. If the

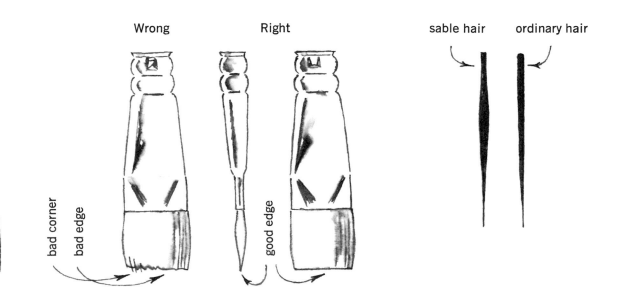

Wrong Right sable hair ordinary hair

bad corner bad edge good edge

resultant edge is sawtoothed or splits, ask for another brush.

Paints, too, should be of the highest quality. Buy paints in tubes so that you can use only what you need. Squeeze them onto a palette; use a dinner plate, a flat enameled pan, or a butcher's tray. If unused colors dry out on the palette, they can be made ready for use again by adding a little water. As a matter of fact, it is very helpful to have cakes built up from unused colors. A further hint, if the caps on the tubes get stuck, as they often seem to, twist first one way and then the other. This failing, light a match and apply a little heat to the cap.

PROFESSIONAL EQUIPMENT

Upper row: Plant irrigator for wetting paper; tissue paper; rinsing water for brushes; sponge for taking up excess water and keeping an edge on brush; clear water to mix with paints and to wet paper.

Middle row: Block of watercolor paper; brushes; palette with colors.

Bottom row: No. 2 pencil; kneaded eraser; sash brush of bristle and ox hair for wetting paper.

LIST OF COLORS

(*) You must have these colors
(C) Complete palette
(EX) Extensive palette

YELLOWS
(*) Winsor yellow
(C) Cadmium yellow pale
(C) Cadmium yellow deep
(*) Indian yellow
(*) Cadmium orange

REDS
(EX) Cadmium scarlet
(*) Cadmium red deep
(*) Winsor red
(*) Alizarin crimson
(EX) Rose madder genuine

EARTH
(*) Burnt sienna
(*) Burnt umber
(*) Raw sienna
(*) Raw umber

VIOLETS
(EX) Cobalt violet
(*) Winsor violet

BLUES
(*) French ultramarine
(C) Cobalt blue
(*) Winsor blue

GREENS
(*) Winsor green

BLACKS AND GRAYS
(*) Payne's gray
No blacks
No whites

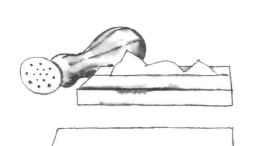

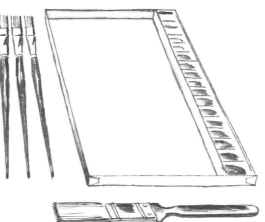

Stroke Technique

Let us begin by making a few basic practice strokes with the No. 20 brush. Using painting strokes, mix thoroughly some Payne's gray with water in a large area of your palette. Make sure that your brush has a knife edge before you start to paint. Place a piece of dry practice paper (the classified section of the newspaper will do nicely) on a flat surface, such as a table top, where you can work standing up. Hold the brush perpendicular, with the painting edge parallel with the hand of a clock as it would be at 12 o'clock. Now, so that we can direct the movement the brush will describe, think of the side of the brush pointing toward the center of the dial as the "red" side of the brush, and the side pointed toward the clock's numerals as the "green" side. In order to keep the direction of the brush clear in your mind while you paint, actually mark the side of the brush to be held toward the center of the dial with a red dot, as illustrated. The unmarked, or green, side will then point toward the numerals of our imaginary clock. When the center of the dial, or the red side, glides, heavy arrows will indicate the direction and length of the glide. Even though this technique for handling the brush may seem a little complicated at first, close attention to the strokes that follow and the illustrations will soon enable you to master this rewarding method of painting.

To begin our first stroke, slowly glide the red side toward you; at the same time slowly turn the green side clockwise to a 3 o'clock

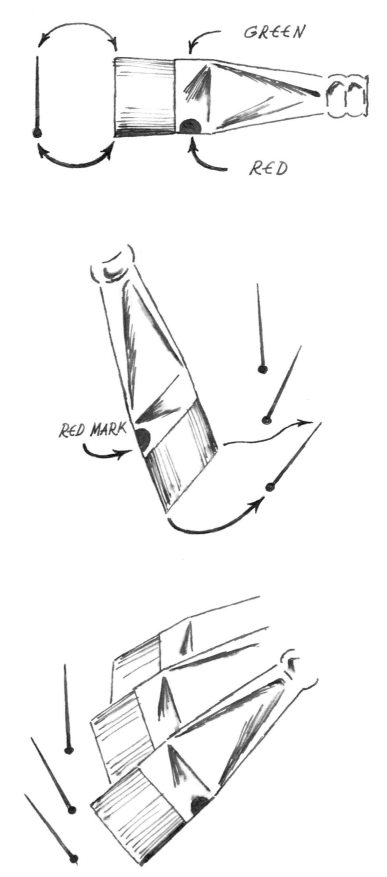

position. Now, keep the red side gliding toward you while you slowly return the green side, counter-clockwise, to the 12 o'clock position (Fig. 1, p. 34). This is the 3 o'CLOCK AND RETURN stroke.

If you continue to glide the red side toward you and repeat the action of the green side, you will make the DOUBLE 3 (Fig. 2, p. 34).

Now, hold the brush as you did above but at a 6 o'clock position with the red side pointing away from you. Keeping the red side stationary on the center of the dial, turn the green side counterclockwise until the brush reaches 3 o'clock. Then slide the red side away from you while continuing to turn the green side until it reaches 12 o'clock (Fig. 3, p. 34). This is the QUARTER SPIN AND SLIDE stroke.

For added practice, hold the brush again at 12 o'clock, the red side toward you. Rotate the green side counterclockwise all the way around, holding the red side stationary (Fig. 4, p. 34). This is the COMPLETE SPIN stroke.

The next stroke is made by placing the green side of the brush at 12 o'clock and rotating it clockwise as you slide the red side in the path described in Fig. 5, page 35. The green side continues completely around the dial. This is the 12 o'CLOCK stroke.

Especially useful for painting the long blades of iris, gladioli, and other linear leaves is the THREE-QUARTER SPIN or 9 o'CLOCK stroke. As in the 12 o'clock stroke above, the brush starts at 12 o'clock and continues clockwise, but ends here at 9 o'clock (Fig. 6, p. 35).

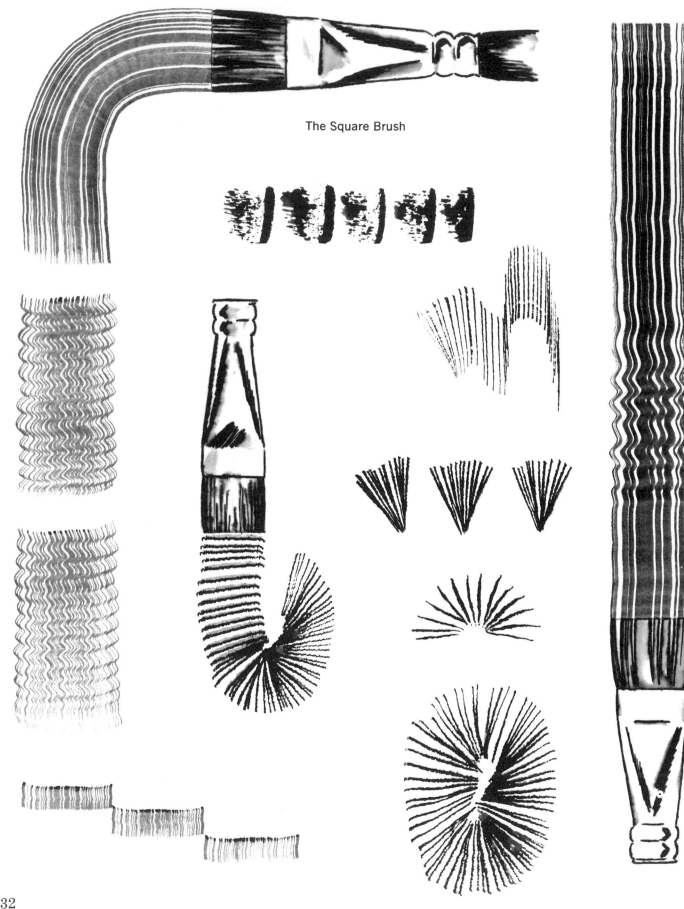

The Square Brush

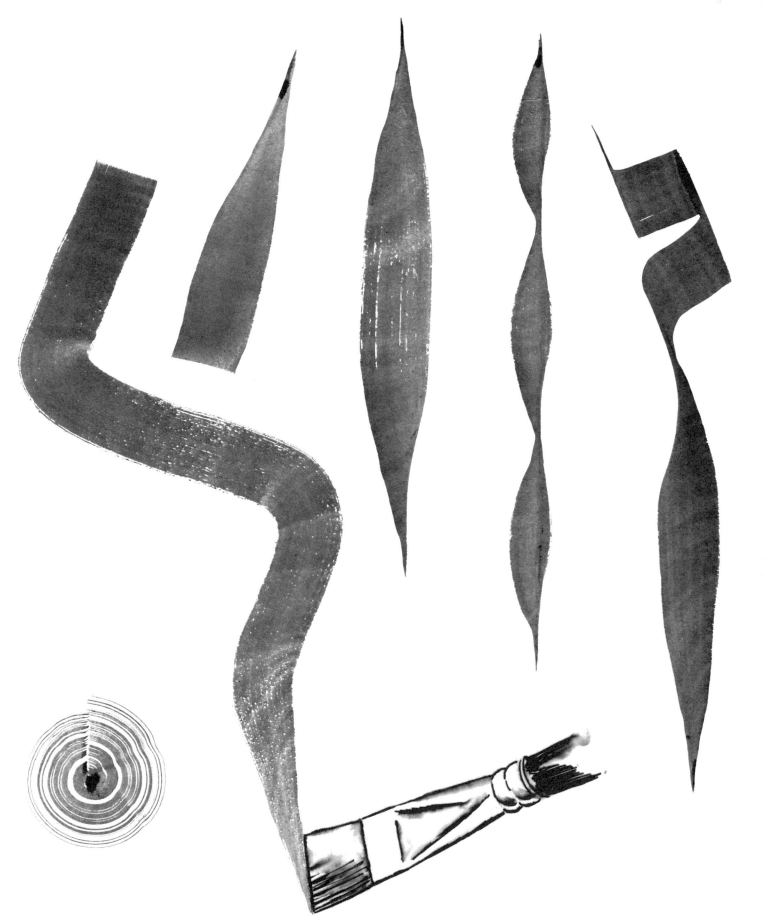

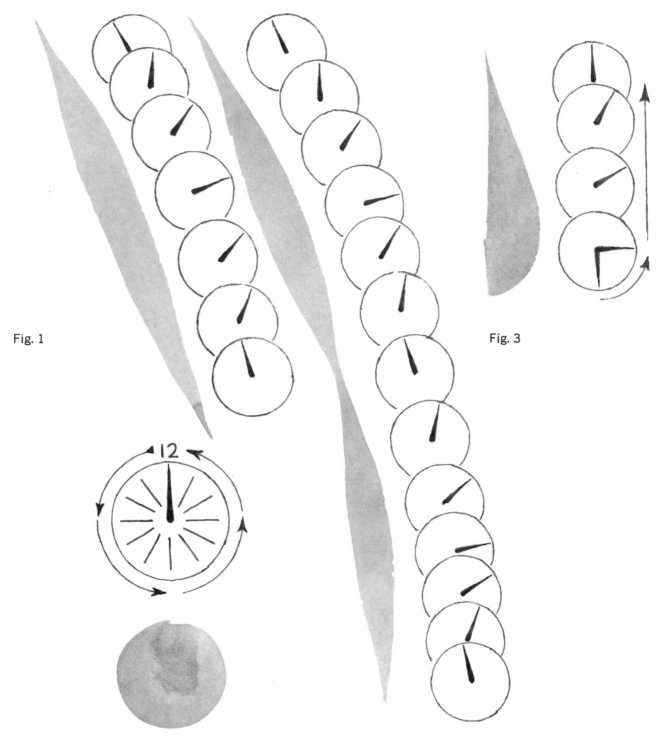

Fig. 1

Fig. 3

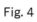

Fig. 4

Fig. 2

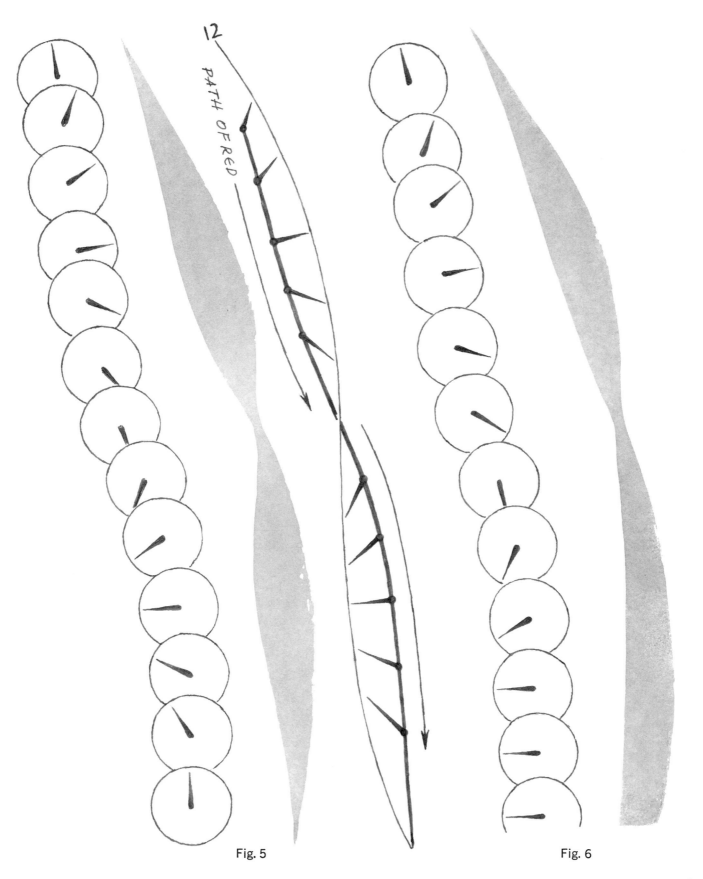

12

PATH OF RED

Fig. 5

Fig. 6

35

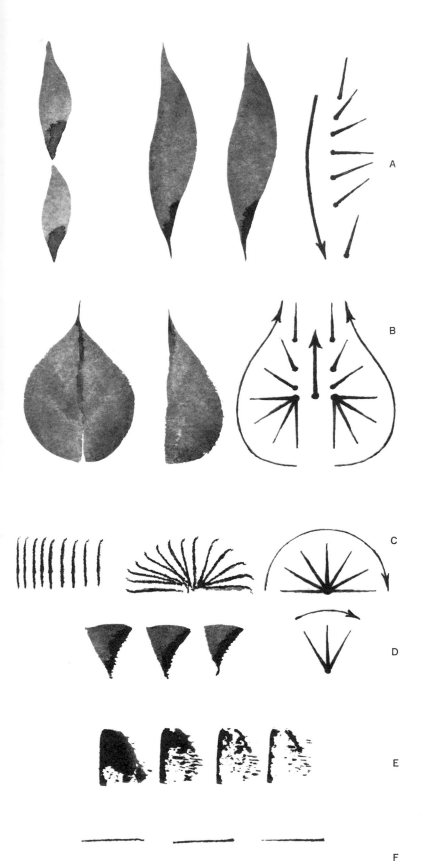

A. THREE O'CLOCK AND RETURN

This stroke is very useful for making small leaves or elements of fern-like (pinnate) leaves.

B. QUARTER SPIN AND SLIDE

This stroke is made either counterclockwise or clockwise. It is used for heart-shaped (cordate) leaves. The leaf on the left was made with two strokes, a counterclockwise and a clockwise quarter spin and slide.

C. HALF-RADIAL CHISEL

This stroke is made by starting the brush at a 9 o'clock position and then, with a pogo stick motion, spinning it toward 3 o'clock on the opposite side of the dial.

D. TEN-MINUTE RADIAL

Keeping the red side of the brush at the center of the dial, spin the green side so that it marks off ten minutes.

E. THE PAT

This stroke is made by holding the brush in a horizontal position, as if you were going to make a line, and then laying the brush down.

F. CHISEL LINE

This line is made by shaping the brush to a fine edge on the sponge, much as you would sharpen a chisel on a whetstone. Holding it in a vertical position, touch the paper lightly. When doing this it is well to steady yourself by putting your other hand flat on the table.

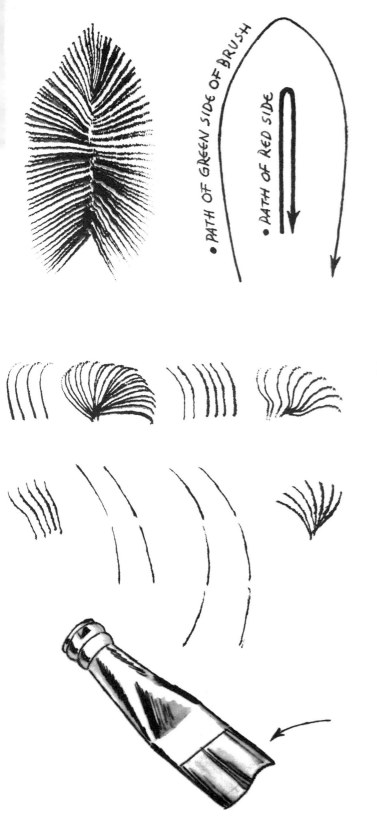

A. RADIATING BACKBONE

This is a series of chisel-like strokes extremely useful for ferns, as in the example shown at the left. The brush is held at a 7 o'clock position, then with pogo stick motions it is turned clockwise until the green side reaches 5 o'clock. The backbone is made the desired length by vertically advancing the red center of the dial. Ferns made clockwise will allow you to see your strokes as you paint them. If you make them counterclockwise, your brush and your hand will screen the area being painted.

B. COMPOUND RADIALS

These strokes are made by shaping the brush. To do this, dip your brush into the pigment and, after bringing it to a knife-like edge, shape the edge to any reasonable shape with your fingers. You will be delighted with the effects you can achieve.

These are the brush strokes used in making
the sketch on the opposite page. They were
made on dry paper. Where the pigment grad-
uates from dark to light, a second brush was
used in the manner described on page 64 un-
der "Two Brushes."

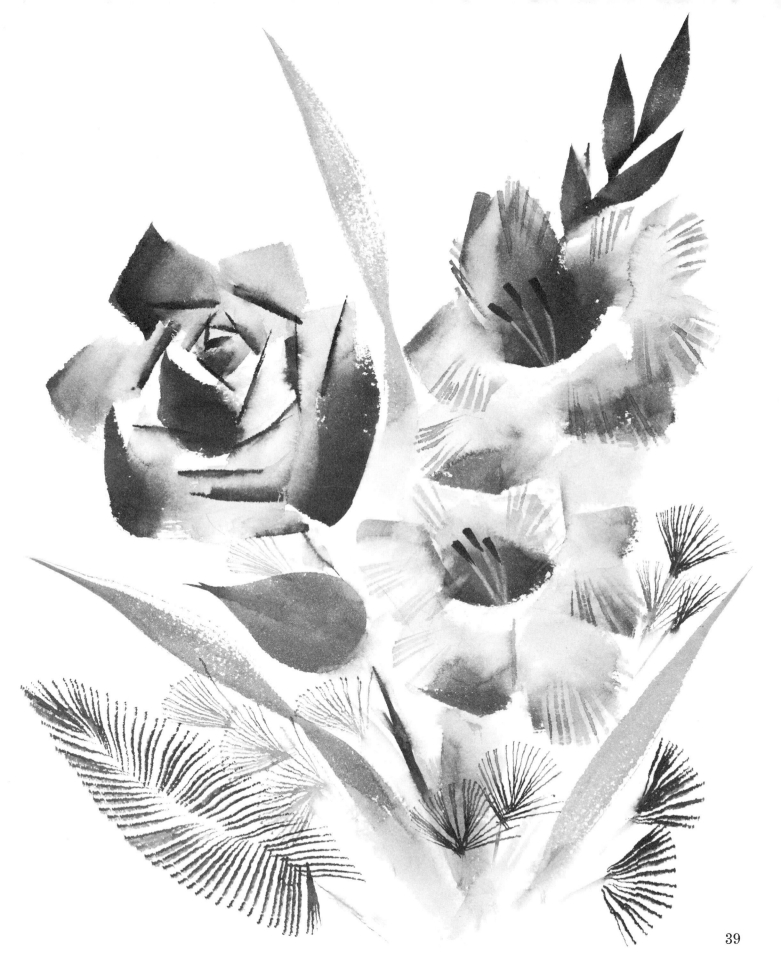

The leaf on the left was painted in one continuous stroke with a No. 20 brush. The brush was held vertically at the bottom in a 6 o'clock position. Then, by using a clockwise spin of the green side while the red side (pointed toward the center of the dial) moves vertically all the way up to a 12 o'clock position, we have half of the leaf. On reaching this point, the position of the brush is vertical and in place to start the downward part of the stroke. The upward and downward stroke constitutes the COMPLETE DIAL LANCE.

The figure on the right shows the upward and downward parts of the stroke.

This diagram shows the position and action of the brush for the COMPLETE DIAL LANCE on the opposite page. The leaf could be done with two separate strokes, but doing it with a continuous stroke teaches excellent control — and that's important!

Learning to paint this leaf will enable you to adapt the same technique to other large leaf forms. It is composed of six strokes. The left half of the leaf was painted with clockwise strokes starting at the bottom. The right half of the leaf was painted with counterclockwise strokes. On the opposite page is an analysis of the strokes.

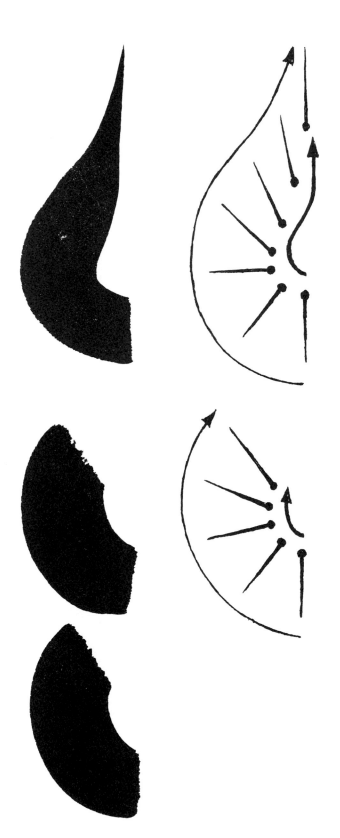

This is like the QUARTER SPIN AND SLIDE except that in this stroke you don't keep the center of the dial constant. As soon as you start this stroke, the center of the dial (the red side) begins to describe a semicircle and ends in a tapering glide at 12 o'clock.

This illustrates the first part of the above stroke and was made with a No. 20 brush. On the following page are more strokes based on this combination, but executed with continuous movement.

Fig. 1 Fig. 2

Fig. 1 on the opposite page diagrams a brush stroke starting at the bottom in a 6 o'clock position. Make the first turn clockwise until reaching 10 o'clock, and then rotate the red side of the brush counterclockwise until it reaches 2 o'clock. Now again turn the green side clockwise to 10 o'clock; and repeat the counterclockwise motion with the red side to 2 o'clock. Finally, slide the green side clockwise to the 12 o'clock position.

Fig. 2 shows the extension of a continuous brush stroke, after having reached the 12 o'clock position, to complete the leaf by gliding on down the right side. Note the dry brush effect at the end of the leaf indicating the spent paint.

Fig. 3 shows the same leaf being made with two strokes; that is, the brush was replenished at 12 o'clock for the downward stroke. Also, the left side of the leaf was overlapped slightly on the down stroke.

Fig. 3

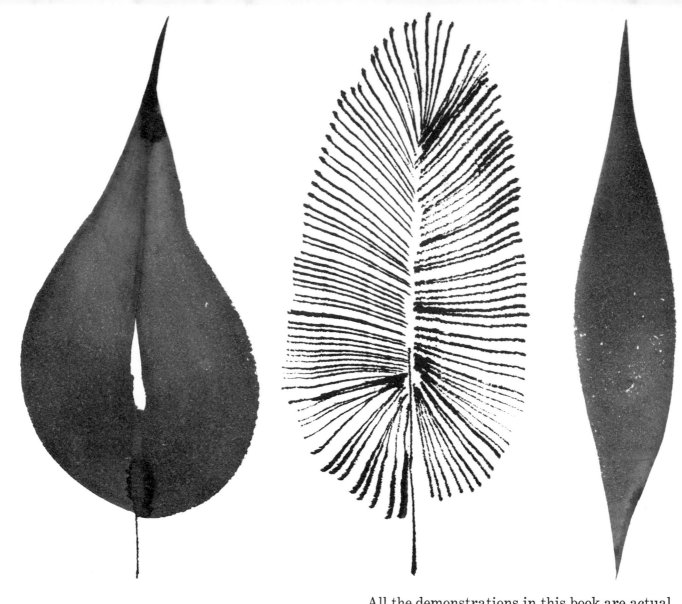

All the demonstrations in this book are actual
size. Those on this page were made with a
one-inch flat brush, which, when wet and full
of pigment, can make a chisel-edge line from
an inch to an inch and three-quarters in
length.

The leaf on the upper left was made with
two strokes: a clockwise and a counterclock-
wise QUARTER SPIN AND SLIDE (p. 34). The
fern-like leaf in the center is a RADIATING
BACKBONE made clockwise (p. 37). The leaf
on the right is a THREE O'CLOCK AND RETURN
(p. 34).

The lower figure was started with a series
of chisel strokes followed by a counterclock-

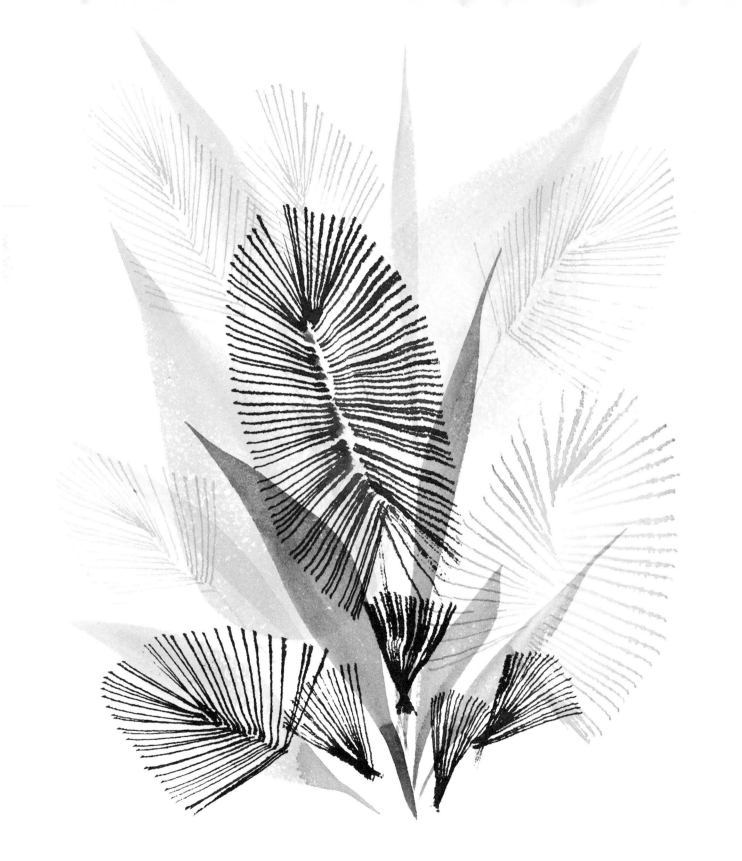

wise spin. On this page are strokes made with a one-inch brush on dry paper. Note the variations made by the use of pigments of different intensities.

Fig. 2

BRUSH WITH PAINT CLEAR BRUSH

Fig. 1

DRY OAK LEAVES

Dry oak leaves can be maddening to paint if they are not approached with a proper technical point of view. Painting the subtle forms and lines of leaves is really closely related to the art of the calligrapher. We shall use our flat brush much as the ancient calligrapher used his quill or flat point pen to render thin and thick lines.

Fig. 1 shows one of the basic strokes used for painting dry leaves. It is made by holding the brush at the 9 o'clock position, while then describing the loops from left to right, repeating this action all the way to the top.

For Fig. 2 the brush is held in a 12 o'clock position, while the loops are made downward, moving from left to right. The light part of Fig. 2 was made with a separate brush containing only water, no paint, by picking up the pigment from the previous stroke.

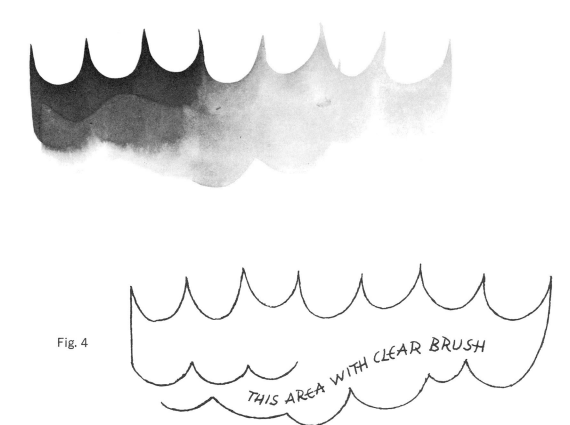

Fig. 3

Fig. 4

THIS AREA WITH CLEAR BRUSH

The stroke used in Figs. 3 and 4 is like the one in Fig. 2, except that here the brush dipped in clean water touched the underside of the first three loops on the left, at the same time softening the edge and absorbing some of the pigment which was used to finish the other loops. This "clear brush" technique will be discussed more fully later under "Two Brushes."

The stroke used in Fig. 5 was made with the brush moving from the 9 o'clock position clockwise to 3 o'clock. The varying lengths of the loops are more in the nature of what you would employ in making dry oak leaves.

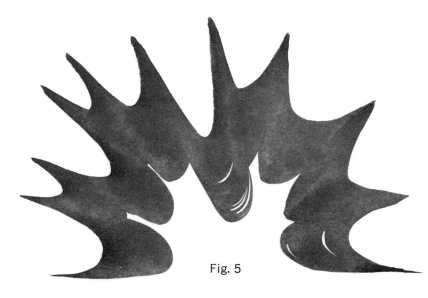

Fig. 5

Finished oak leaves made with the brush strokes described on the preceding pages and employing the two-brush technique (see p. 64).

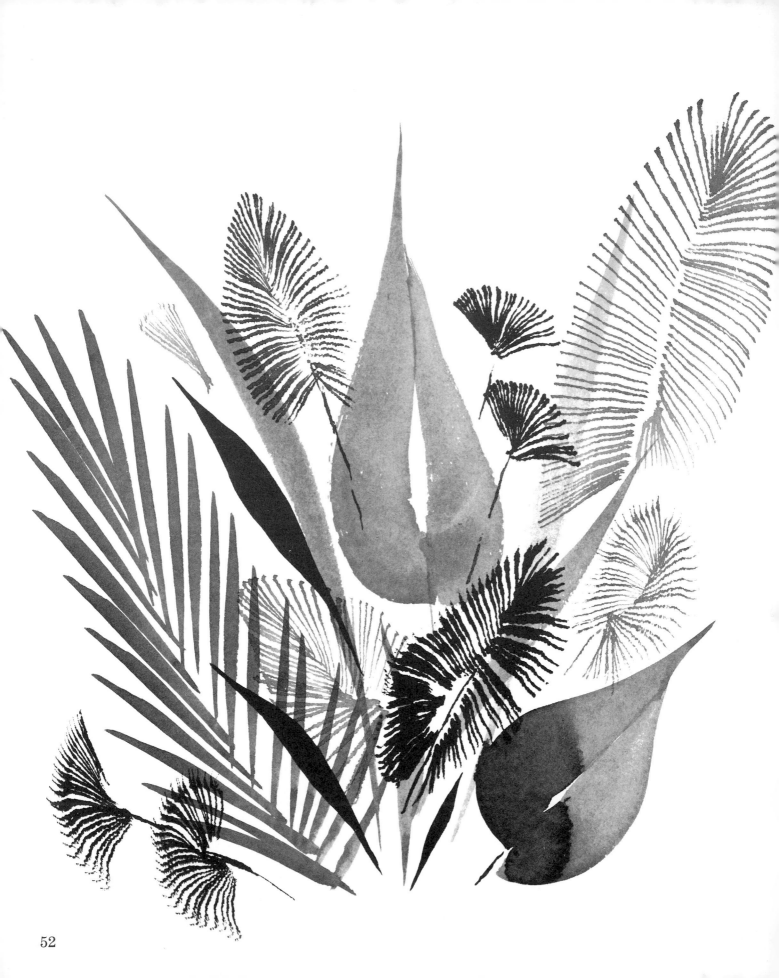

Painting on Dry Paper

The seven brush strokes on the following pages demonstrate the effects of painting on dry paper. They were all made with a No. 20 brush, using the THREE O'CLOCK AND RETURN stroke (p. 34).

Fig. 1
The pigment is not too heavy, and just a little water is added. Note the dry brush effect on the 2 to 4 o'clock edge of the stroke.

Diagram showing overlapping technique used to create varied tones when working on dry paper. Finished painting on opposite page.

Fig. 2
More water and pigment are added for this stroke. A very wet stroke leaves a clean edge.

Fig. 3
Still more pigment is added, but the brush is wiped against the side of the palette or the sponge to take off some of the water. Note a little dry brush effect on the right side.

Fig. 4
For this brush stroke all excess water was removed; consequently a heightened dry brush effect was achieved.

Fig. 5
The paint used for this edge was very soupy and thick—hence the clean edges.

Fig. 6
As in Fig. 5, the paint is thick, but some of the water was taken off the brush.

Fig. 7
This brush stroke, from which all excess water was sponged out, carried very thick pigment, resulting in a more pronounced dry brush effect.

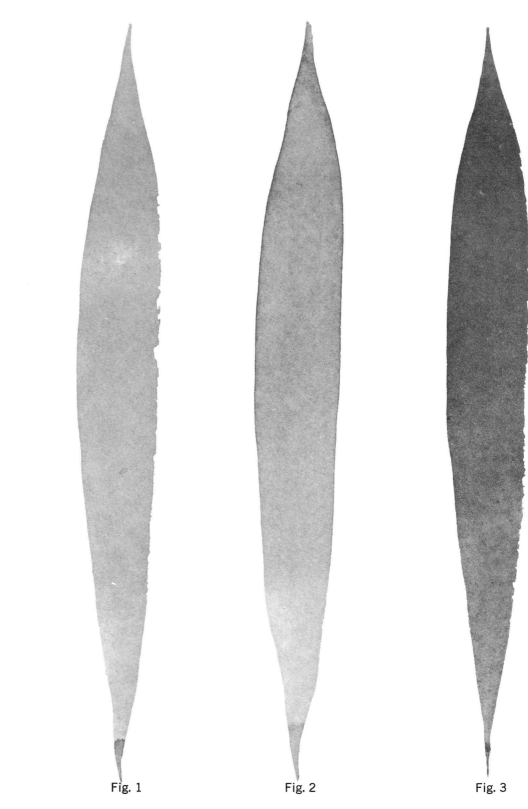

Fig. 1 Fig. 2 Fig. 3

For practice and experience you should try these exercises. They will acquaint you with the behavior of brush, paint, water, and paper.

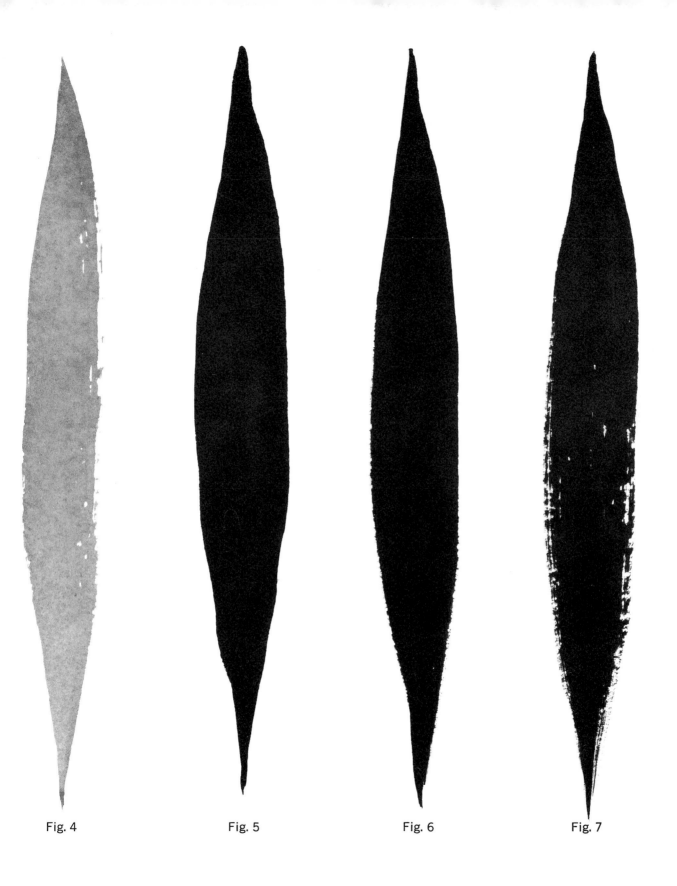

Fig. 4 Fig. 5 Fig. 6 Fig. 7

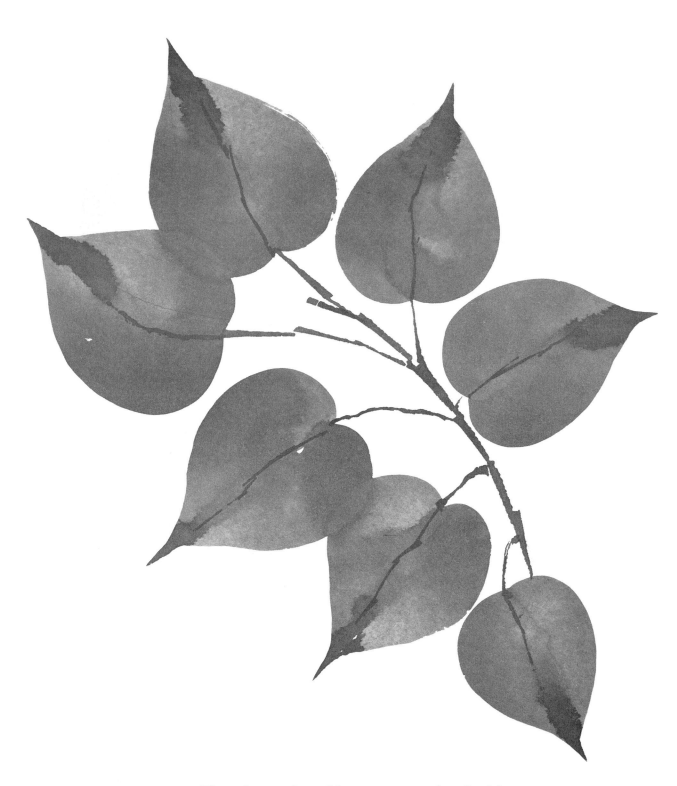

These heart-shaped leaves were painted with
a No. 20 brush on dry paper. The stroke used
is the QUARTER SPIN AND SLIDE, clockwise and
counterclockwise (p. 34, Fig. 3).

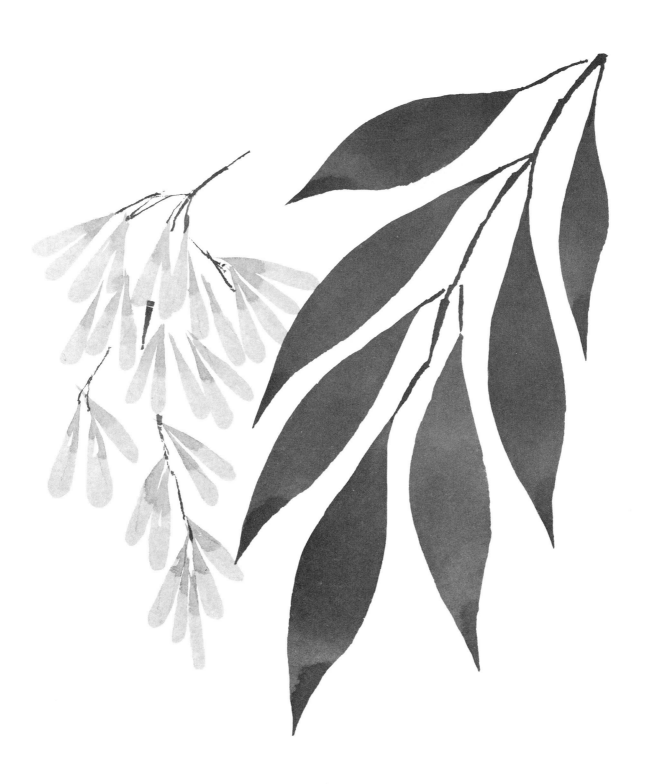

The smaller leaves, or key fruits, on the left
were painted with a No. 14 brush; the larger
leaves with a one-inch brush.

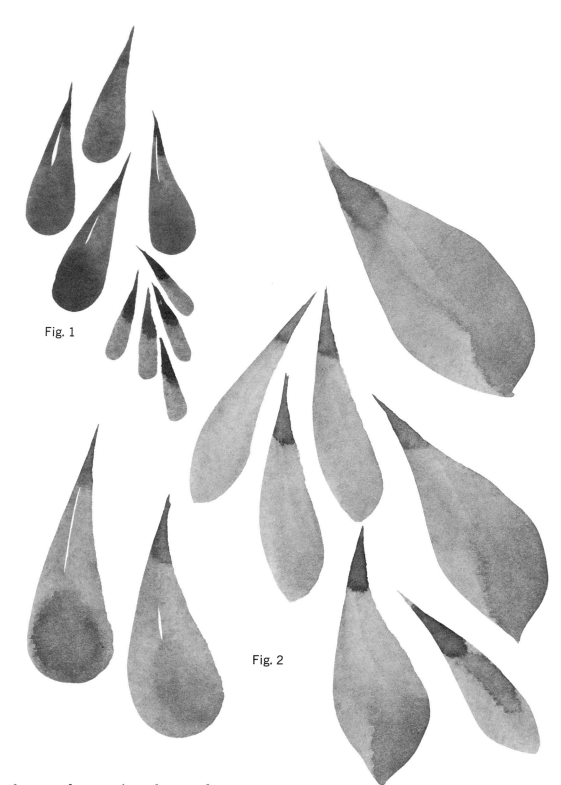

Fig. 1

Fig. 2

The brushes used to paint the strokes on these pages are as follows: Fig. 1, a No. 14 brush; Figs. 2, 3, and 4, a No. 20 brush; Fig. 5, a one-inch brush. The strokes are described on pp. 60 and 61.

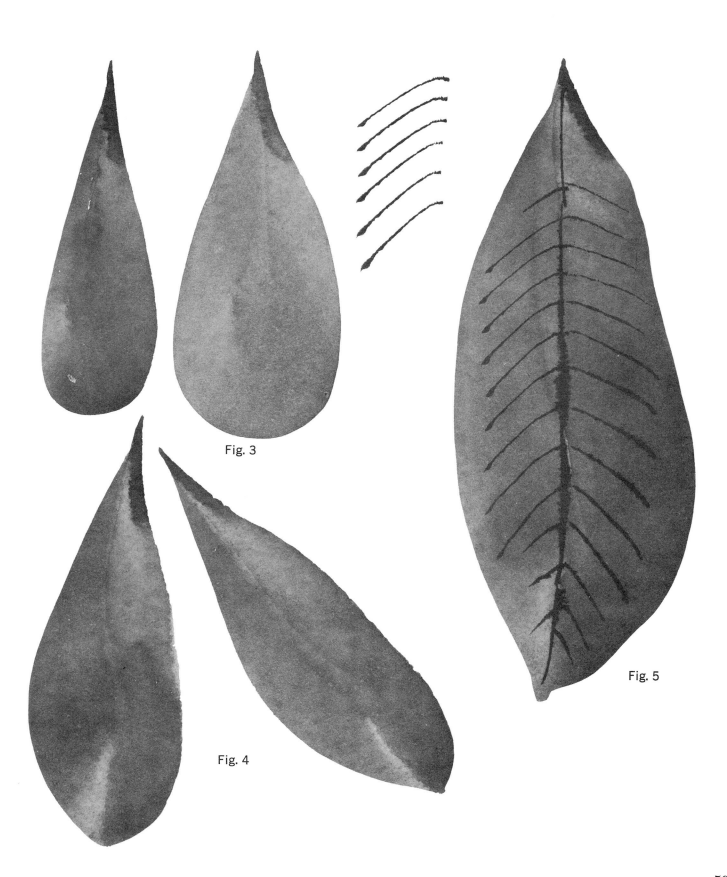

Fig. 3

Fig. 4

Fig. 5

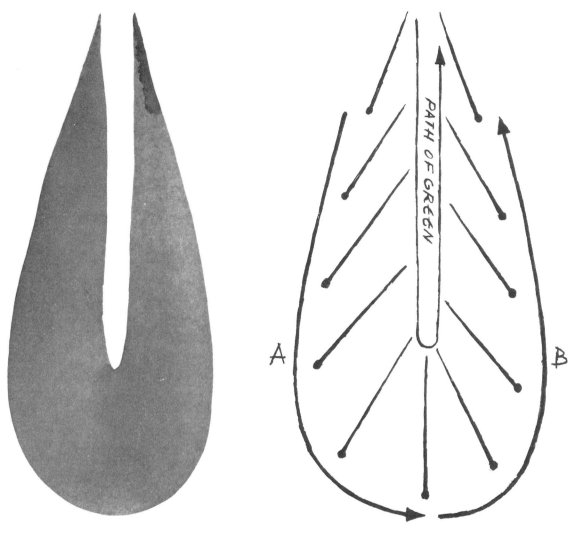

Fig. 1

Fig. 2

Fig. 1 demonstrates the stroke used to paint the smaller key fruits on p. 58. This large-scale version, which would be appropriate for bigger forms such as magnolia and rhododendron leaves, is included to facilitate diagrammatic explanation. In actual practice the downward stroke on the left should overlap the upward stroke on the right. In this diagram they are deliberately left open in order to illustrate more clearly the path of the brush.

Fig. 2 indicates the direction the brush takes in describing this form. The stroke starts on the upper left-hand side at 1 o'clock. As the downward glide progresses, the green side of the brush turns toward 2 o'clock. It holds this direction until it reaches point "A," where it begins to assume a direction toward the center of the dial, while the red side glides counterclockwise until the green side is pointing toward 10 o'clock. On reaching "B," the green side glides up to 11:30.

Fig. 3

Fig. 4

As in Fig. 1, the leaf in Fig. 3 is shown divided in order to facilitate explanation. This leaf differs from that on the opposite page in that the left downward stroke keeps its original angle (2 o'clock) for almost its entire length. The angle shown at point "A" in Fig. 4 is held until the stroke reaches point "B," resulting in a fairly sharp angle at the base of the leaf. From here the red side spins very fast until reaching "C," then continues its upward glide.

Pressure on the brush will increase the width of its stroke. Just how much pressure will cause the brush to respond as we wish it to, only experience and practice can teach us.

DRY BRUSH

The term "dry brush" is used to describe the painting technique wherein the pigment does not entirely cover the area of the stroke. This results in spots of white paper showing through the paint and in uneven edges, particularly on rough paper. To achieve these effects, very little water is mixed with the paint—just enough to apply it to the paper. The consistency of the paint should be more syrupy than soupy.

The three examples on the opposite page show the effects of the dry brush technique on handmade Winsor and Newton, "ACM," rough-textured, 140 pound paper. The leaf forms on this page were painted on a rougher textured paper.

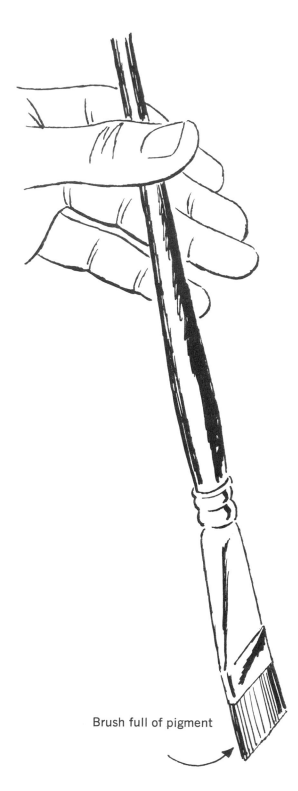

Brush full of pigment

TWO BRUSHES

One of the keys to good painting is a wide variety of edges—soft, sharp, thick, thin, turning, fading, irregular, flowing. The possibilities are limitless.

In watercolor the soft fading edge is of primary importance. Some artists achieve soft edges by using a sponge, others scrape or erase. But I want you to learn to *paint* them, using the two brush technique. The method is this: Brush number one is used, in the normal way, to paint onto the paper as

much or little of the pigment as is desired. Then, while the paint is still wet, brush number two, with no color and drained of excess water, is substituted. Now, picking up where you left off, continue the stroke with this clean brush, which will absorb and paint with the pigment left by brush number one. As it does so, of course, the tint will become lighter and lighter, until the line is almost transparent (see pp. 66-67). This method was used for the dry oak leaves on pp. 50 and 51.

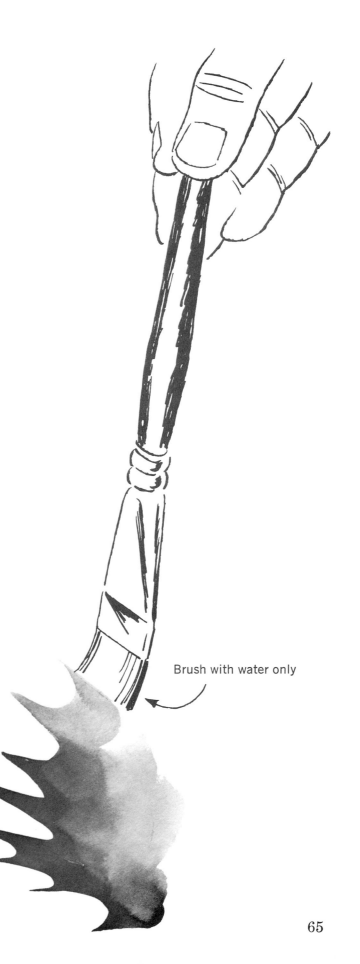

Brush with water only

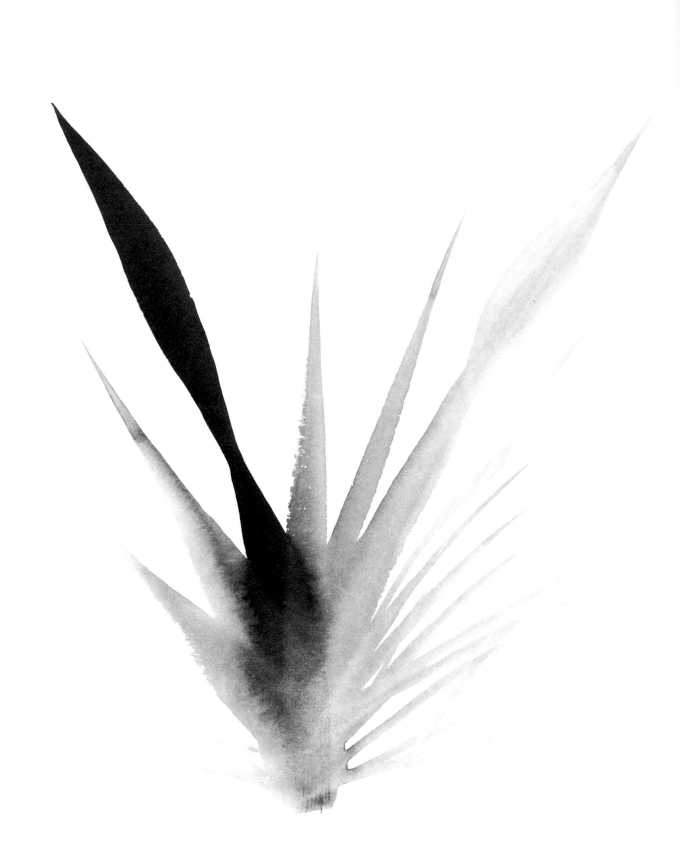

Two-brush technique.

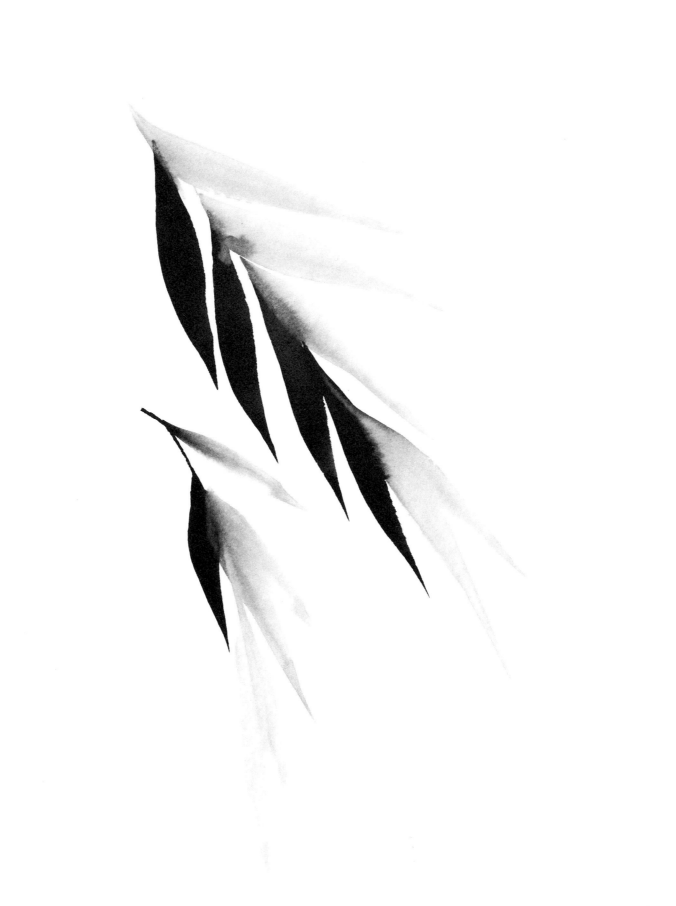

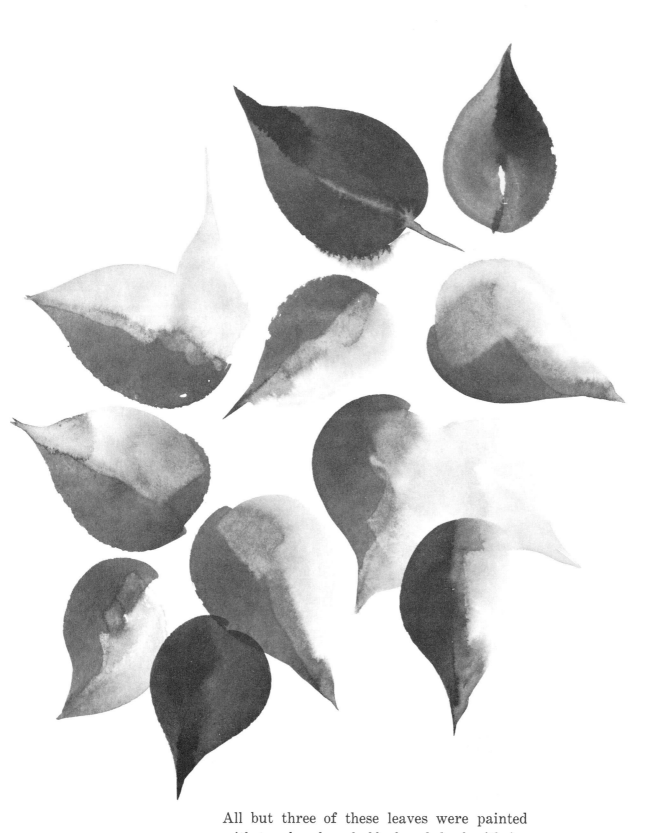

All but three of these leaves were painted with two brushes; half of each leaf with intense color and the other half with paint borrowed by the clear brush.

These three-lobed maple-like leaves were painted first with intense color on the top lobes, then the clear brush was used to pick up the pigment and paint the second and third lobes. Notice how much lighter the third lobe is.

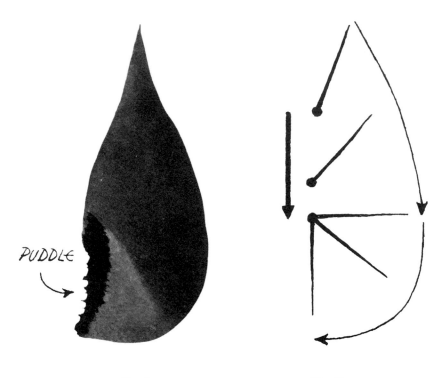

PUDDLE

Fig. 1 Fig. 2

Fig. 1 shows the first passage of the three-lobed leaf illustrated on page 69. It is accomplished as shown in Fig. 2: From the 12 o'clock position, turn the brush clockwise to 3 o'clock, at the same time gliding the red side downward and increasing the pressure on the brush. On reaching 3 o'clock, hold the dial (the red edge) steady and continue to spin until you reach 6 o'clock. The brush should be loaded with enough pigment so that upon reaching 6 o'clock it will leave a small puddle. It is this concentration of paint that supplies the second, clear, brush with enough pigment to enable it to paint the two remaining lobes.

CLOCKWISE, SINGLE STROKE

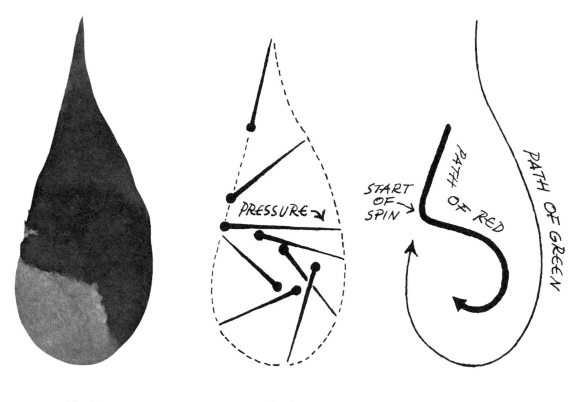

Fig. 3 Fig. 4 Fig. 5

Making an oval leaf with an acute tip as exemplified by the narrow leaves in the painting on pp. 86 and 87 is illustrated in the diagram above. First, make a clockwise stroke as illustrated in Fig. 1, p. 70, until you reach 3 o'clock. Add pressure and continue to spin the brush in the same direction until you reach 9 o'clock.

Fig. 4 shows the positions of the red and green sides of the brush. Fig. 5 indicates the paths of the two sides of the brush.

Practice making leaves with just a single stroke to enrich your technique and control.

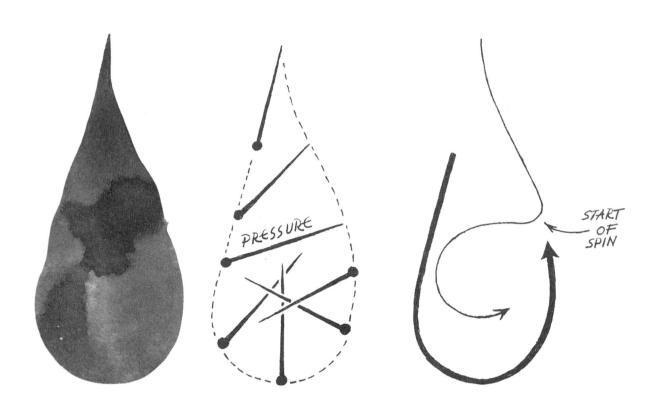

The same leaf made by a counterclockwise stroke is shown above. Again, the first part of this stroke is made as in Fig. 1, p. 70 and Fig. 3, p. 71, until you reach 3 o'clock. Then the red, or dial, side of the brush describes a long sweep from 9 o'clock counterclockwise to 3 o'clock. This type of leaf can also be made with two brush strokes, as was the heart-shaped leaf on p. 56.

Painting in Wet

The technique of painting "in wet," as the name implies, involves working on wet paper so that pigment applied by the brush is further diluted on contact. For the greater freedom and speed required of this method, it is best to stand while working. Painting a watercolor in wet is rather like an artistic

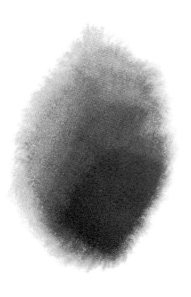

Diagram showing flowing technique used to create varied tones when painting in wet.

fencing match between artist and paper, using brushes as foils; and you cannot fence sitting down.

The paper should be stretched or in a block (see p. 26) and in a flat position. Use a large brush to wet the paper; a sash brush made of ox hair will do, and it doesn't cost much. Brush the water onto the paper with sweeping strokes, striving for an even film, until the paper is saturated. This requires patience. The paper will buckle, but this won't matter provided puddles don't form in the valleys.

Another way to wet the paper is to soak it thoroughly in a large container of water. Paper prepared this way does not require stretching, as it will remain flat, as long as it is wet, on any water-repellent surface.

But we are getting a little ahead of ourselves. First you should sketch in pencil a few guide lines on your paper. Do not be concerned with detail at this point; leave that for the painting. Next, mix your main colors on the palette, for once you have wet the paper you will need all the time before the paper dries for the actual painting, not for mixing and looking for colors. Now, wet the paper as described above. When the water stops running, and while the paper still has a good shine, you are ready to start painting.

←

Effects of same brush stroke on paper differing in degree of wetness:

On left, brush strokes made on dry paper with little water and very thick pigment.

Center, brush stroke made on paper much too wet for any control. Consequently, paint puddles made "blossoms" as paper dried around them—an interesting effect achieved by accident. Uncontrolled strokes are unpredictable—as likely to spoil as to enhance.

On right, paper is not as wet, but still too wet for complete control.

Remember the following:

1. Watercolor dries about two to three values lighter, so paint your colors correspondingly deeper.

2. Your paper is already wet, so your brush and paint should contain less water than when working on dry paper.

3. Try to get all your tints and middle tones on your first wetting.

4. Should your paper start to dry, try to work on the areas that are still wet. *Under no condition* try to rewet the paper at this time. *This is very important.* When the paper is in this stage, surface tension is still in effect, and to wet it would be like cutting a hole in a high tension net. You will have to wait until it is completely dry. This won't take more than ten or fifteen minutes. It takes a great deal of patience, an important part of our study.

When the paper is dry and you have waited the necessary time for the paint to set, then it is possible to wet a section at a time. Try not to sweep back and forth with your brush as you did when you first wet the paper. It is best to wet only the section you are going to paint on, and lightly, just enough to prevent getting hard edges where you don't want them. If you wet a section lightly, you won't disturb the underpainting, and you will be able to blend your overtones with your undertones.

5. The dark accents should be put on last, wetting sections of the painting where needed. If you put the dark accents in first, you may find they are out of key with the rest of the painting.

A final note: good watercolorists think nothing of doing a painting over again, sometimes many, many times.

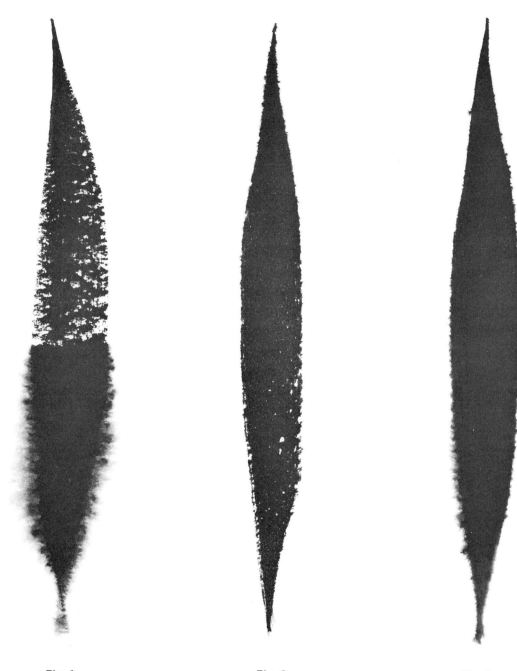

Fig. 1 Fig. 2 Fig. 3

In Fig. 1 the paper was half wet and half dry. The pigment was very thick and without much water. The resultant dry brush effect disappeared the instant the brush touched the wet half of the paper. For Fig. 2 very thick pigment was applied to an almost completely dry, rough paper. Fig. 3 shows the same brush stroke on a smooth paper with

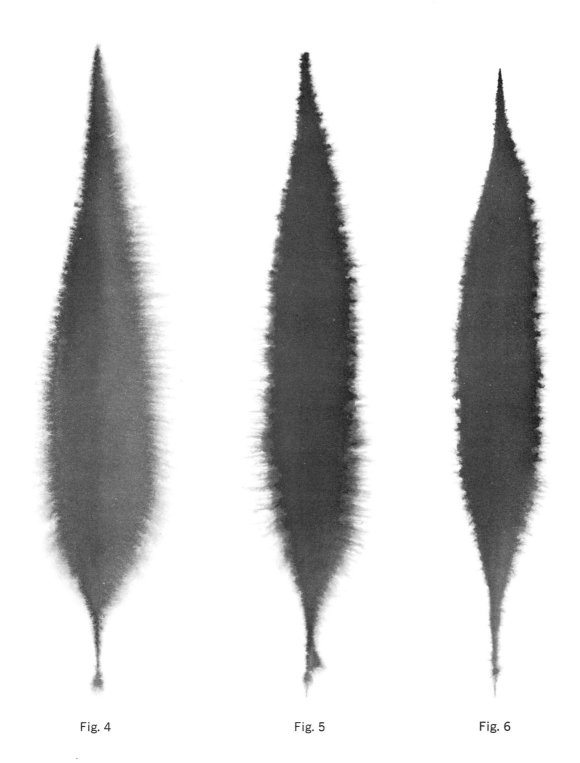

Fig. 4 Fig. 5 Fig. 6

the same degree of moisture.
Fig. 4 shows the first of three brush strokes made on paper with a light film of water. The stroke in Fig. 5 was made two minutes after that in Fig. 4. The stroke for Fig. 6 was painted two minutes after that in Fig. 5. Notice how the brush strokes became thinner as the paper gradually dried.

Here a brushful of paint was applied to dry
paper. The slender strokes radiating from
the initial one were painted without the use
of additional pigment.

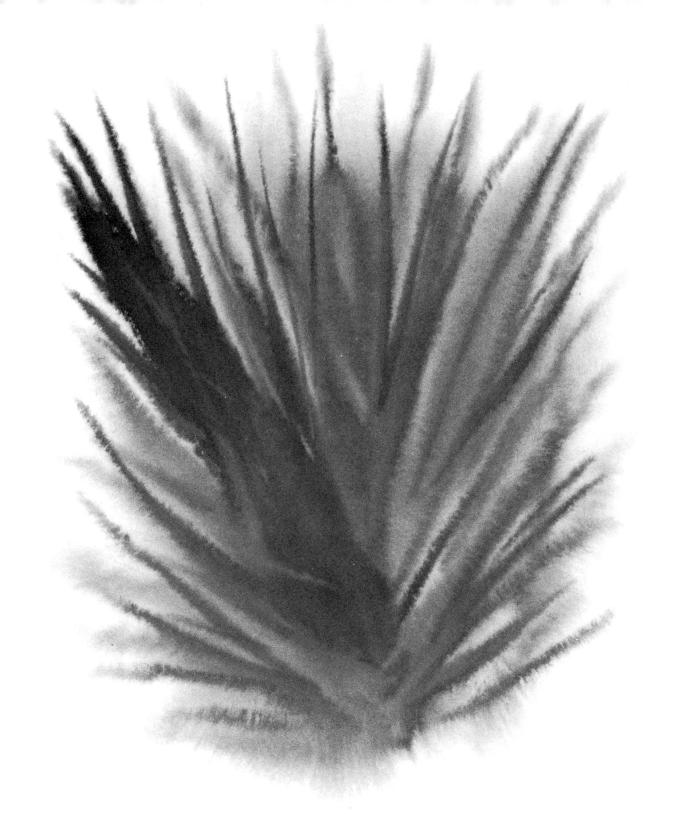

And here a similar brushful of paint was applied to wet paper. Notice the mist-like result. It is this effect that is most flattering as a background.

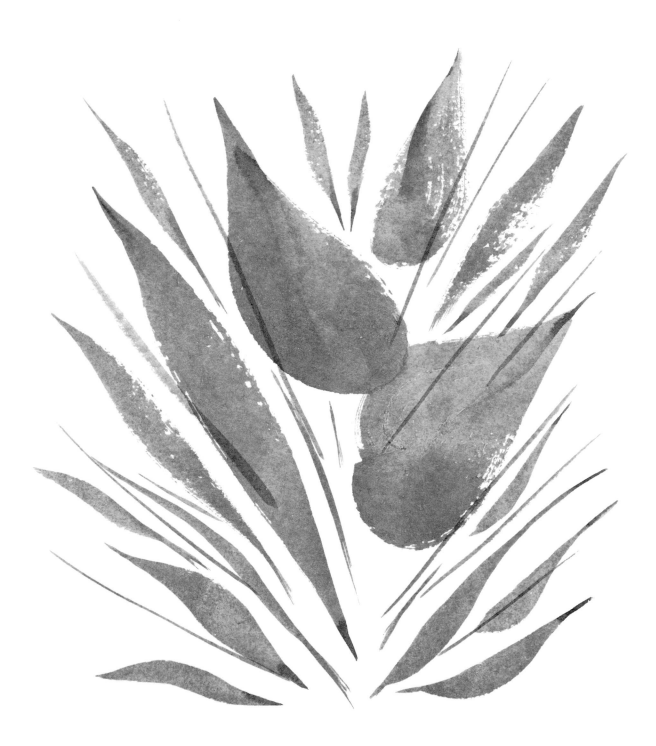

When building up a background, try to give
the mist some shape or design, such as distant
leaves, trees, or some kind of structure. Above
are the shapes and strokes used in the ex-
ample on the opposite page.

If the paper is properly damp, the brush stroke should diffuse and give the effect of mist. One should strive to get a silvery mist, a feeling of quiet glitter. The value of the tone should be about No. 5 (see chart p. 89).

Let's Paint a Picture

Using some of the strokes already studied, we are ready to paint a picture in the in-wet method. With a small preliminary sketch to guide your ideas, draw in the main areas of the composition. But do not indicate every detail; leave some of them for spontaneous delineation as you paint. Following the instruction on the preceding pages, mix your paints and *then* wet your paper, being sure you have an even film of water covering the sheet.

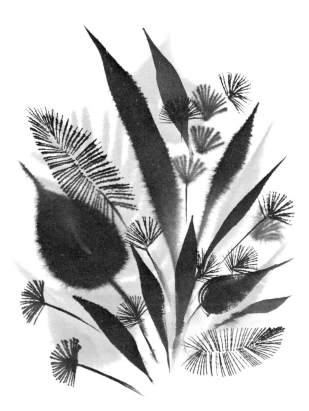

The three illustrations (in monochrome) that follow demonstrate the stages in the build up of an in-wet painting.

Step one, p. 83, involves painting in the misty background while the paper is still fluid.

In step two, p. 84, the darker elements with sharper edges are added.

In step three, p. 85, the forms with the sharpest edges are put in.

Should your paper dry before you finish painting, wait about 20 minutes before wetting it again, as suggested in the chapter entitled "In Wet." Be sure to wet the paper beyond the particular area you want to paint so that the paint won't "catch up" with the surrounding dry surface and make a hard line.

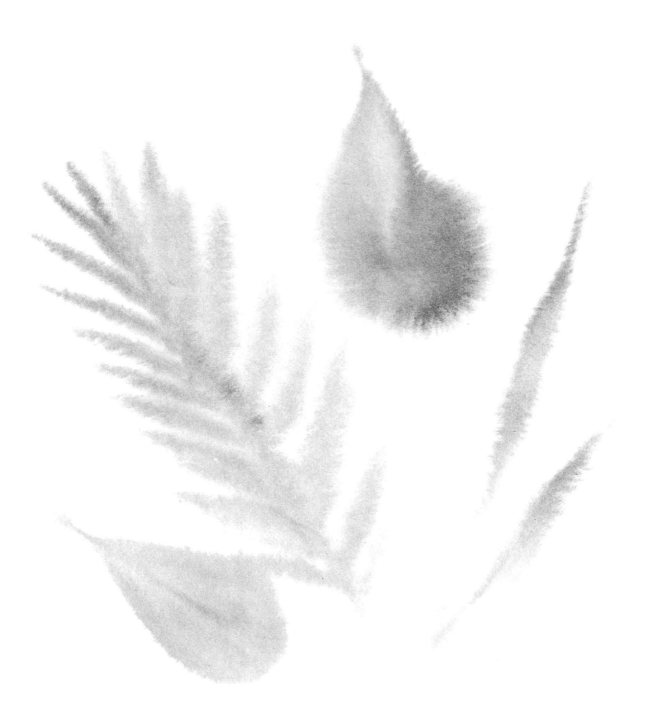

Begin by painting in the misty background.

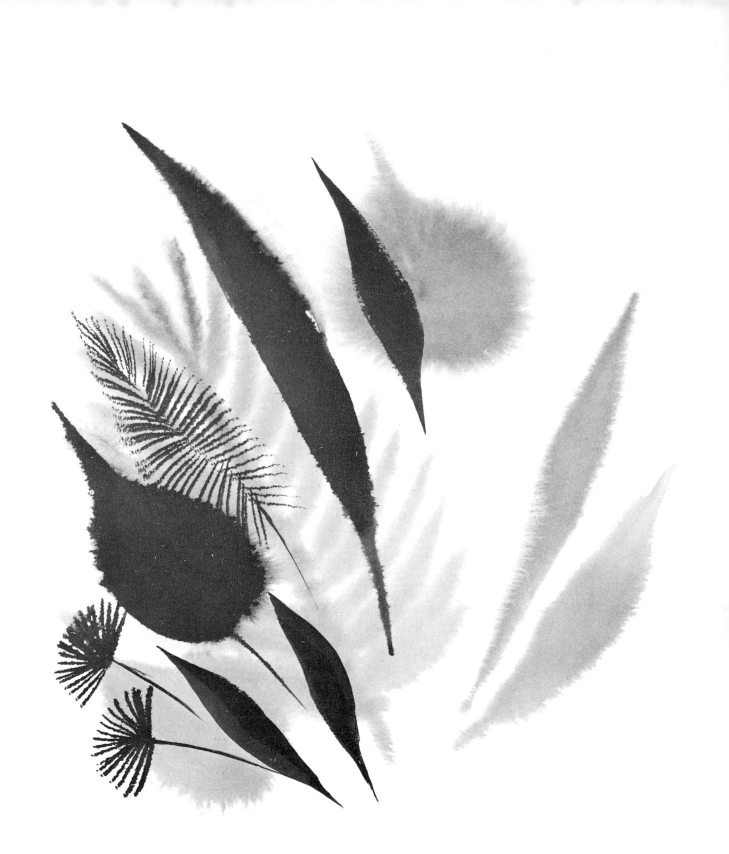

Later the darker elements with sharper
edges are added.

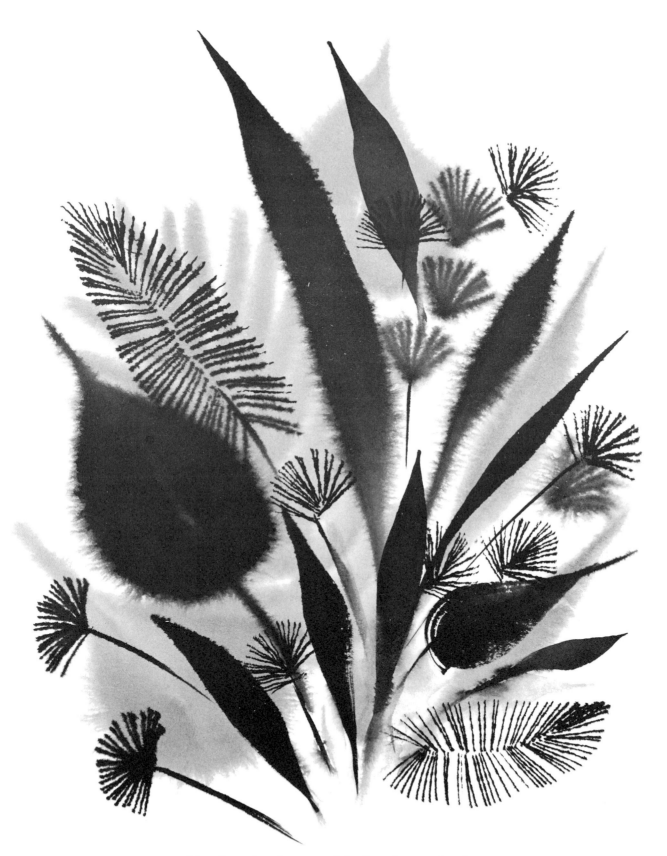

Finally, the forms with the sharpest edges
are put in.

Flowers Mean Color

The reason so many of us paint flowers is because of their beauty of color, shape, and form (volume). Remember, when consider-

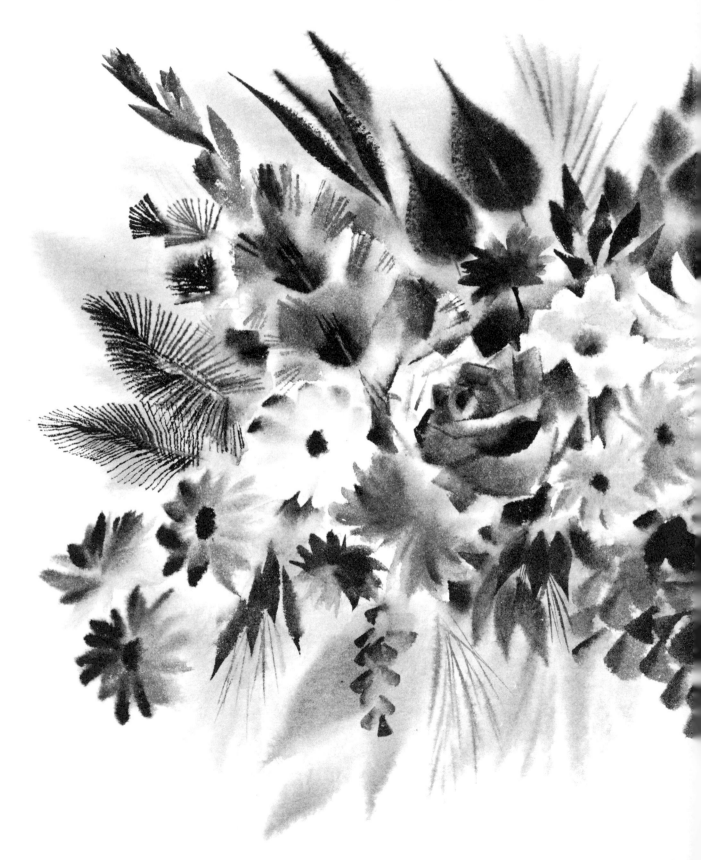

ing these elements, that you are a painter, not a horticulturist. Your interest lies in a successful artistic interpretation of flowers based upon these elements — not an anatomical description of specific types.

Color is perhaps the most important con-

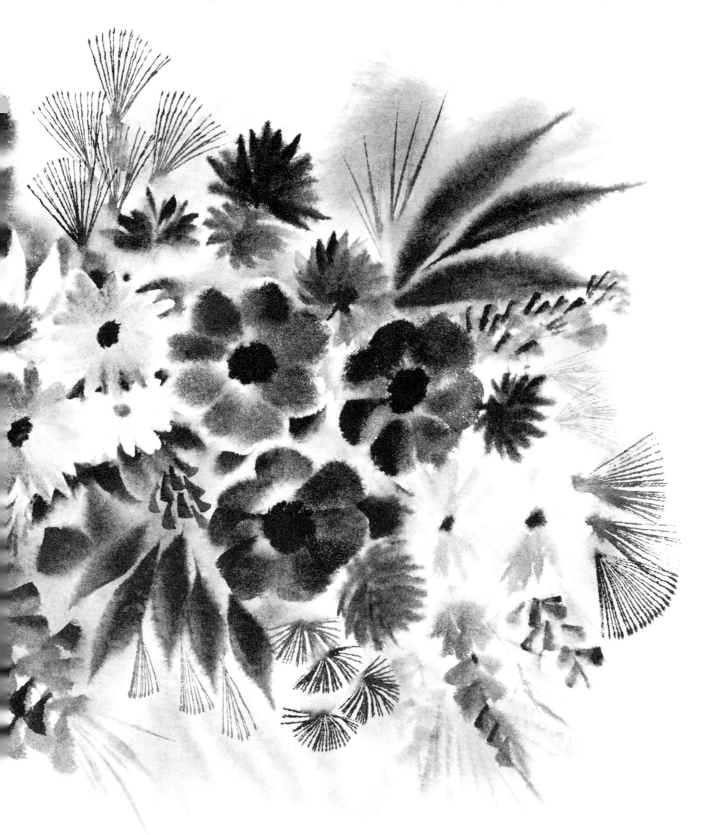

sideration when capturing the beauty of flowers. So we will begin by defining some terms necessary to an understanding of its uses. Each color (or hue) contains a potential of white and black. These three major elements, *hue*, *white*, and *black*, can be expressed as an equilateral triangle (below). Within this triangle, by relating and combining the three elements, lie all the possible variations of a single color.

As an example we will use red, full strength, straight from the tube. Now, if we mix red and white in equal amounts, the result is a *tint*, in this case pink. If we mix equal portions of red and black, the result is *shade*. Equal portions of white and black produce *gray*. If we now mix equal amounts of red and gray, the result is *tone*. So we see that every color has seven elements: hue, white, black, tint, shade, gray, and tone.

By mixing the seven elements with each other, it is possible to get forty-five distinct variations from one color — think of that! If you were using orange and red you would have 90 variations to work with.

Anyone interested in studying color more fully should read the books by Faber Birren on this subject.

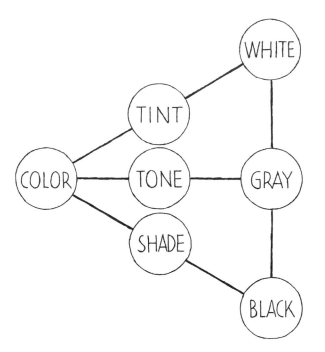

VALUE

Value, the lightness or darkness of a color, is produced by the intensity of light on or from a color. To best illustrate the variations of value, I have used black and white for their simplicity, on the theory that white represents the presence of light and black its

$$\frac{100}{0}$$ = *1*

$$\frac{87\frac{1}{2}}{12\frac{1}{2}}$$ = *2*

$$\frac{75}{25}$$ = *3*

$$\frac{62\frac{1}{2}}{37\frac{1}{2}}$$ = *4*

$$\frac{50}{50}$$ = *5*

$$\frac{37\frac{1}{2}}{62\frac{1}{2}}$$ = *6*

$$\frac{25}{75}$$ = *7*

$$\frac{12\frac{1}{2}}{87\frac{1}{2}}$$ = *8*

$$\frac{0}{100}$$ = *9*

absence. Using a color wheel, I have equally divided nine different steps from white to black, starting with white as value no. 1, with its formula of $\frac{100\ white}{0\ black}$, and ending with black as value no. 9, with its formula of $\frac{0\ white}{100\ black}$. The intermediate values have been graded into seven middle values, such as $\frac{50\ white}{50\ black}$, which is value no. 5.

This is an elementary value chart, but it will do for our purposes. Thus, if we indicate the use of value no. 5, we mean a value which corresponds to that of equal amounts of white and black. All colors in their unmixed, pure state correspond to specific values. For instance, pure, raw yellow resembles value no. 2, while ultramarine blue, a much darker color, corresponds to value no. 8, or no. 7. You can lighten ultramarine in value, up to no. 5, for example, by thinning it with water.

When the proportions illustrated on the left of page 89 are rotated on a wheel, they will produce the gray values on the right.

TRANSPARENT WATERCOLOR

A very important thing to remember when painting with transparent watercolor is that tints and white areas are not created with white paint, as they are in the opaque or oil techniques. As we have already discovered, such areas are the result of the white paper being left uncovered or showing through diluted pigment. For example, red greatly thinned by water will permit the white paper to show through, resulting in pink. In the same way, gray can be made simply by thinning the black pigment with water. The thicker the pigment, the less paper will show through, resulting in a darker color.

The tendency of the beginning watercolorist is to use too much water, especially when working with the in-wet technique. Remember that you will be working against a brilliant white background. Your aim will be to control artistically the amount of light by either revealing it by thinning the pigment with water or blocking it out with tints, hues, tones, grays, shades, and black. How much light shows through and its effect will depend upon your mastery of the technique and your imagination.

The diagram, page 91, shows how color is affected when the paper is used as white. Color plus water, plus the white of the paper equals tint. Black plus water plus the white of the paper equals gray. Color plus black equals shade. Color plus black plus water plus paper equals tone. Of course you must use water with all colors, even if you are trying to get black. But remember, more water means lighter color, less water darker color.

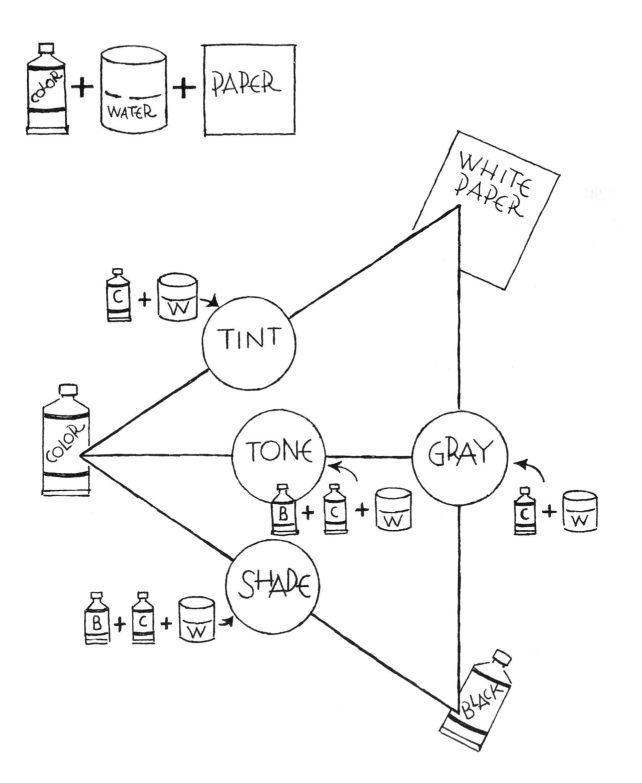

COLOR + WATER + PAPER

C + W → TINT

WHITE PAPER

COLOR → TONE ← B + C + W

TONE ← GRAY ← C + W

B + C + W → SHADE

BLACK

MIXING COLORS

You can purchase an almost infinite variety of fancy colors, but when you mix them together you are apt to end up with a lot of mud. For our purposes, the basic colors listed on page 29, handled well, will do very well and produce sparkling paintings. The new chemical dyes have produced new, clear colors that have replaced others less brilliant and permanent. However, I shall not take your time to go through the chemical origin of the colors. It suffices to say that alizarin crimson is a lake prepared from 1:2 Dihydroxyanthraquinone, and that Winsor green is Chlorinated Copper Phthalocyanine, and so on.

Although color mixing can be a highly individual matter, learned only by patience and practice, a few mixing facts, gleaned from wide experience, can be of great help.

Colors suggested for their tinting power and versatility are: Indian yellow, Winsor red, alizarin crimson, Winsor green, Winsor blue, and Payne's gray (instead of black, as it is clearer when mixed with other colors).

Indian yellow, when mixed with other colors, will retain its identity without getting milky or dirty.

Winsor red mixed with Winsor blue makes a rich steel-gray purple. If you use it straight on a wet surface, it will run, a tendency to remember for its advantages and disadvantages. For example, if you use Winsor red carelessly on a face to paint the lips, it may run all over the chin.

Alizarin crimson mixed with ultramarine blue will produce a purple; with burnt sienna, a very rich, warm earth.

Winsor green is the only green I recommend. You probably won't want to use it right from the tube, but when it is mixed with all the earths and yellows, it produces a wide range of greens. Winsor green mixed with raw sienna produces olive green.

Winsor blue when mixed with alizarin crimson produces a delightful color called steel. Mixed with raw sienna and raw umber it will give a gray green which can be very rich. Mixed with yellows, of course, it will give greens.

Payne's gray when applied thickly will look black. Add alizarin crimson and you will get a red black. The addition of Winsor blue to Payne's gray will produce blue black.

The earth colors I recommend are true earth colors; sienna and umber are native earths. Burnt earths are just that —calcined or cooked earths.

Flowers—Form and Color

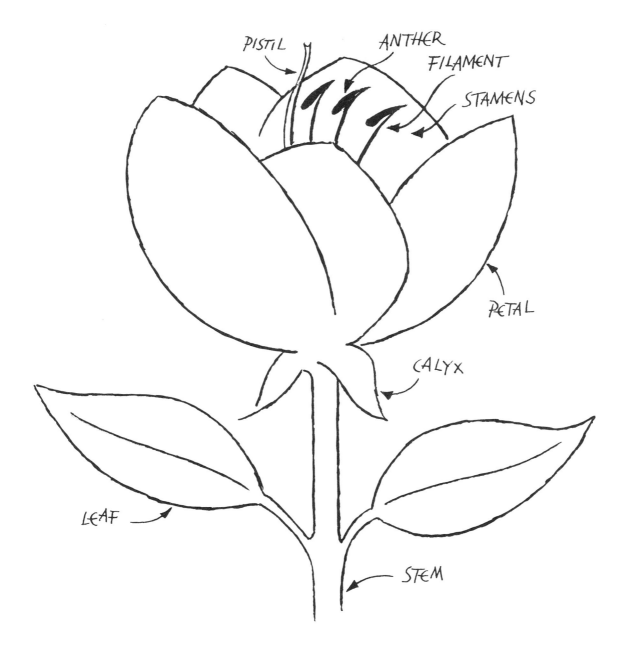

This is an elementary diagram of a flower
identifying the important features. It shows
the stem, leaf, calyx, petal, and the stamens,
which are made up of the filament, pistil, and
pollen-bearing anthers.

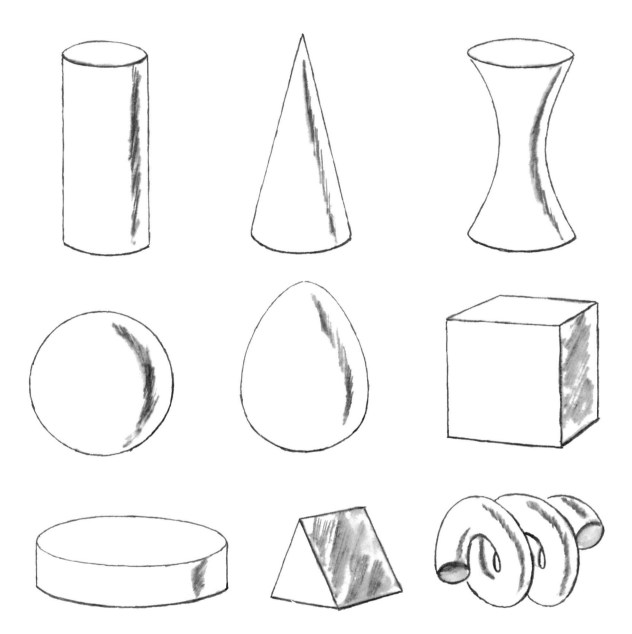

Sometimes we are confronted by flowers that don't seem to lend themselves to solid, three-dimensional forms. They will require a bit of artistic license. The forms sketched on this page are basic. The cylinder can be applied to trunks, stems, and branches. The cone can be combined with other forms to suggest buds, calyx, clusters, or the "funnels" of certain flowers. The cylinder with concave sides, as well as the sphere and the spheroid, or egg-shape, and the drum are all applicable to flowers. The square, prism, and coil are less used, but even these can be applied to certain unusual flower forms or compositions.

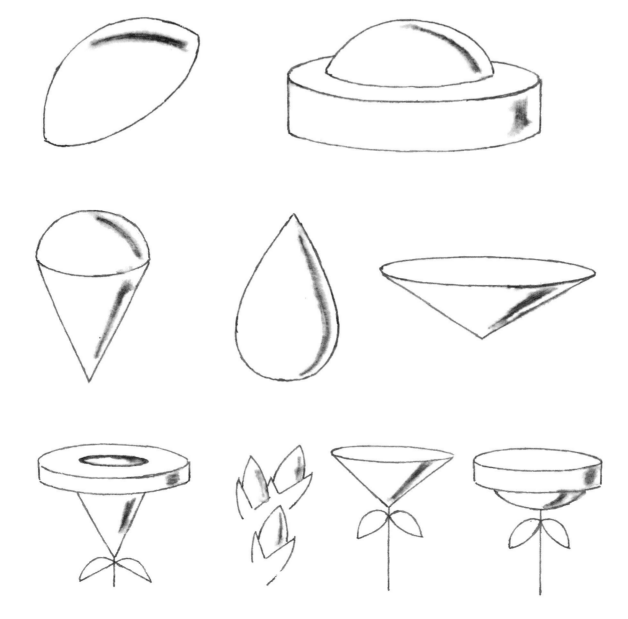

The above, more complex geometric forms could, without too much stretching of the imagination, represent flowers. Many chrysanthemums can be shaped within the hemisphere. The hemisphere over a drum suggests still other flower forms. The carnation could be based on a hemisphere over a cone. The same form could depict a bud. A very shallow cone will describe certain chrysanthemums or daisies. The drum, in combination with the cone, is very common among flower forms. Naturally, there will be flowers that are difficult to put into any of these categories, such as the bird of paradise on page 19.

DAISY

Most beginning flower painters seem to run into trouble when they encounter the daisy. This is usually because they do not allow it to remain white and to have body and breadth in the petals. The result is a starved, spider-like flower (Figs. 1, 4, and 7). To be painted successfully, a daisy must have a strong impact of white in its design, which is based on a scalloped circle (Fig. 2). As you paint the circle of the daisy, you will become more aware of its irregularities (Fig. 3), but it still will reflect the basic geometric pattern.

Fig. 5 shows an inverted cup, or hemisphere-shaped form, and Fig. 6 its advancement into a flower. A different position suggests a different form. Fig. 7 should suggest a fan, as in Fig. 8 and Fig. 9.

Sometimes flowers can successfully be conceived in forms that are not necessarily geometric. Very often they suggest a fish or a bird. Figs. 10 and 11 show a daisy in a position that suggests such a form.

Notes on Demonstrations:

The first step in painting a daisy (pp. 98 and 99) is not to paint it at all, but to build a background around the flower as in Fig. 1, page 98. When the background has dried, pencil in the petals with greater care, and then proceed to define the petals, four and five at a time. Re-wet the paper up to each petal and the area of background that you need for the flow of the pigment (see Fig. 2).

Continue this method all around the flower until you have achieved the degree of definition you want, as in Fig. 3. The finished flower is shown in Fig. 4.

The picture on page 99 illustrates how, once you have the idea of a flower making a white pattern, you can reverse parts of it, making a silhouette. This produces a dramatic, three-dimensional effect.

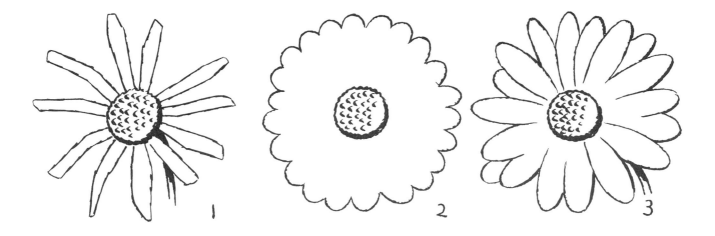

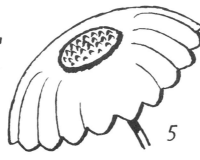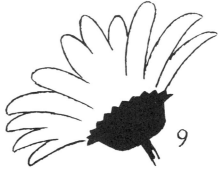

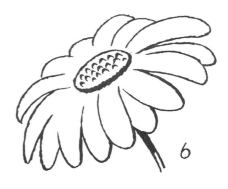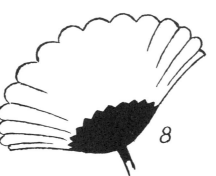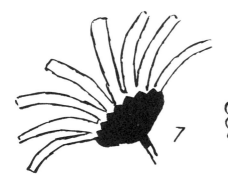

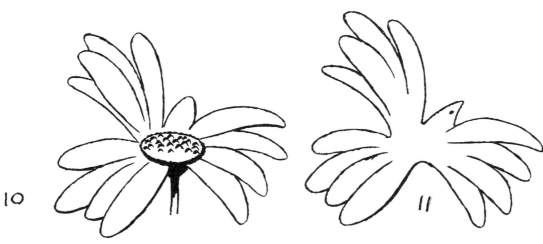

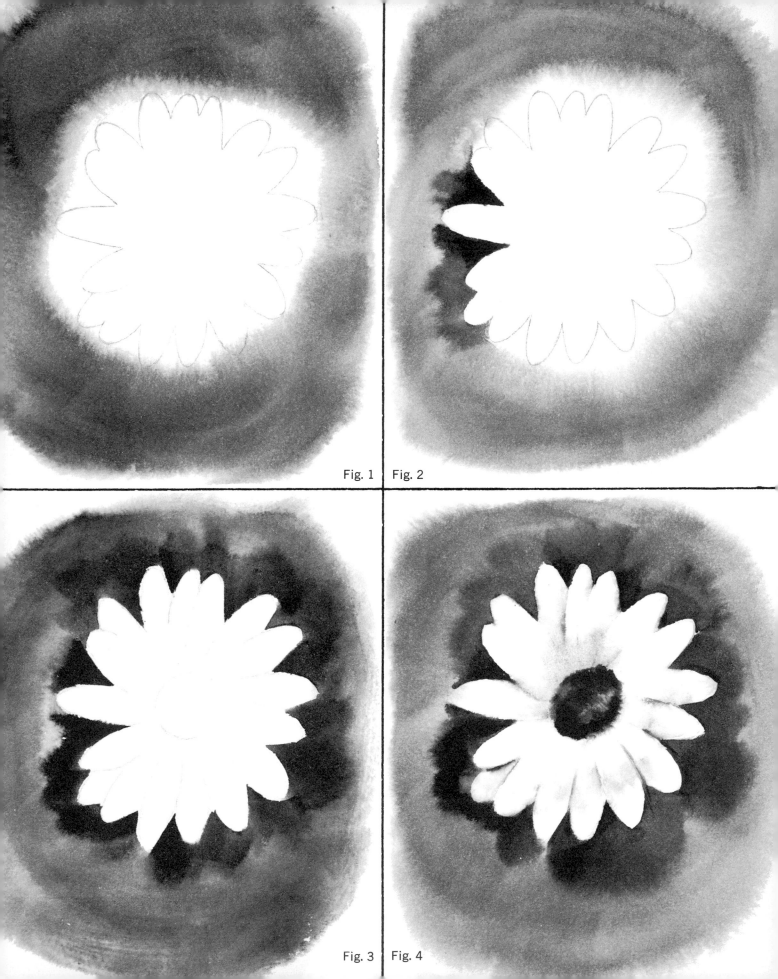

Fig. 1 Fig. 2

Fig. 3 Fig. 4

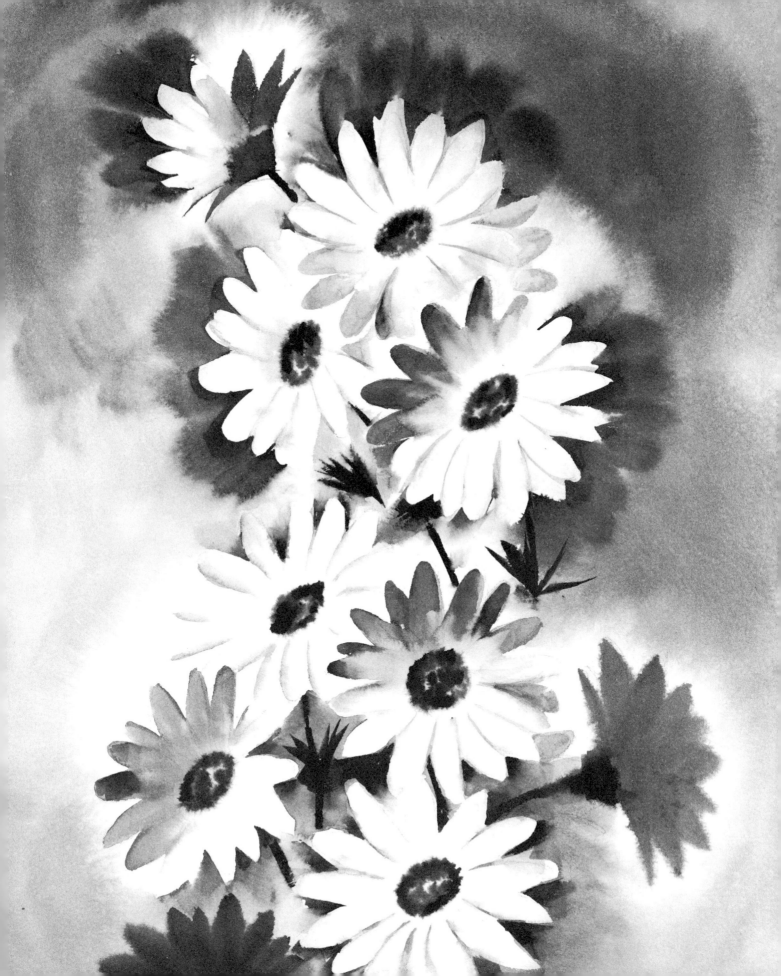

ROSE

There are many kinds of roses, and their structures can differ greatly. The variety could fill an encyclopaedia, from the delicate Cecile Brunner to the huge cabbage rose. However, we are not concerned with botanical distinctions but with painting basic structures and forms. If you can learn to paint one rose well, you can paint any other kind.

A valuable approach to painting any flower is first to determine the over-all linear rhythm of its design. In the case of the rose this is created by a series of sheets (Fig. 1) describing a spiral rhythm around a central cone (Fig. 2). As the sheets rotate, some of them will fold back or become "dog eared" (Fig. 3). The complete flower (Fig. 6) then, is composed of circling sheets, "dog ears," and spiral lines (Figs. 4 and 5).

Notes on Color Plates:

Fig. 1. The first colors are painted on while the paper is at its wettest. Notice the variety of yellows, ranging from Winsor yellow at the top to cadmium orange at 11 o'clock and Indian yellow at 9 o'clock.

Fig. 2. While the paper is still fairly wet, some of the linear accents are painted in so that they will flow slightly and have soft edges.

Fig. 3. After the paper has dried for ten or fifteen minutes, the more definite lines are added.

Fig. 4. Lastly, tone and further color are added, using a "clear brush" to soften the edges and blend them into the rest of the flower. The background helps to define the petals as seen in the petal at 2 o'clock.

The painting on page 103, reproduced actual size, is on D'Arches 300 lb. paper. About ten minutes was spent wetting the paper, brushing on the water to establish a film over the sheet.

1

2

3

4

5

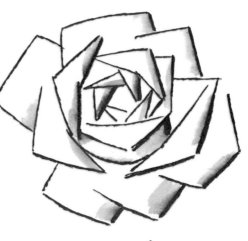

6

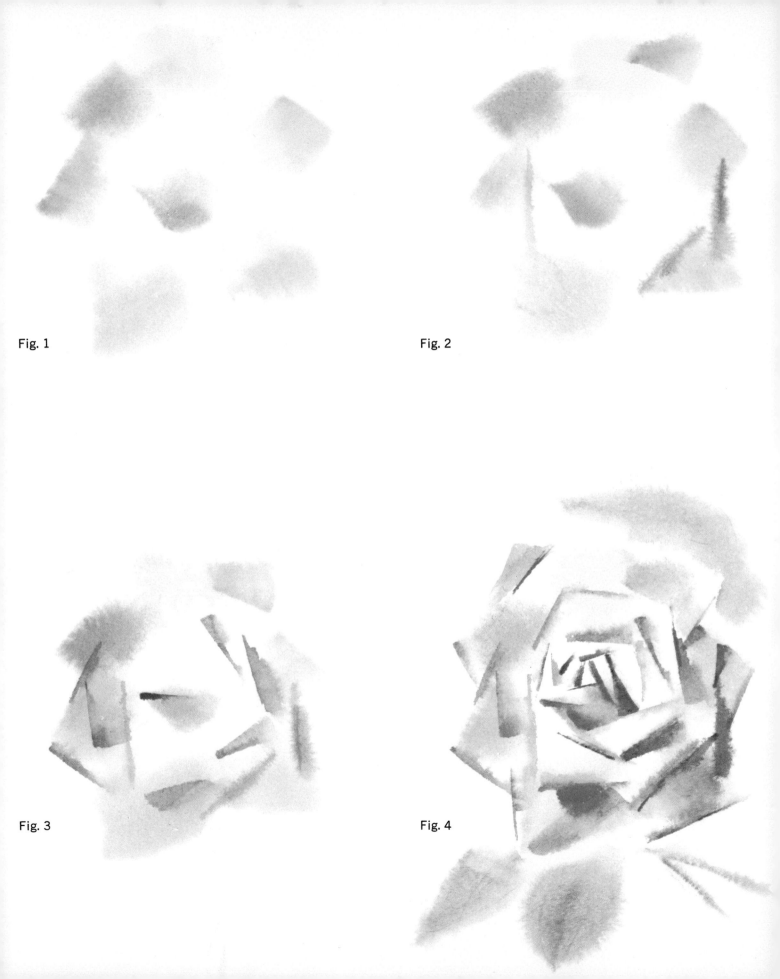

Fig. 1

Fig. 2

Fig. 3

Fig. 4

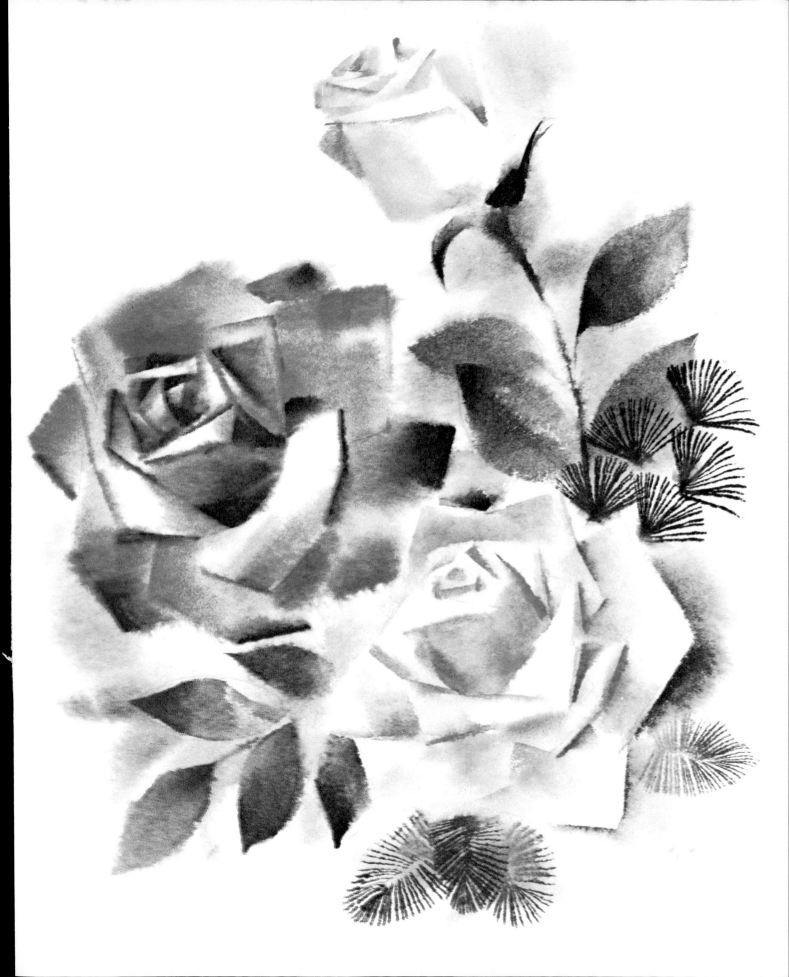

IRIS

Again, as with the other flowers, the problem with the iris is not anatomical but geometrical. The iris can be very complex if not approached properly. This Dutch iris is formed around a triangular shape like an inverted pyramid with three sides (Fig. 7). The three upright petals (standards) look like three wings (Fig. 2), and they are placed between the corners of the horizontal triangular plane. The three oblique petals are actually six. Each one of the three is composed of an upper and lower petal terminating in an open-mouthed section with a yellow tongue. The shape of the open mouth can be compared to a shield with two wings on top, as in Fig. 6. The structure of the slanted petals, upper and lower, forms a flattened cylinder. The spine of the vertical petals (Fig. 3) is very decorative. You probably won't paint the spine but only the terminals as they pass the edge of the petal. The blades around the stalk should phrase with each other to form a series of "V's" (Figs. 4 and 5).

The trick now is to paint the flower with as few strokes as possible. The wings, or uprights, should each be laid in with a single stroke and the accents, making the ruffle-like edges, added later when the paper has dried.

Notes on Color Plates:

Fig. 1. The main color areas are painted in wet.

Fig. 2. After the paper has dried somewhat, the deeper tones are painted in, using a clear brush to soften the edges.

Fig. 3. The petals are further developed by the addition of channeling, made with the edge of the brush. The clear brush was used to soften hard edges and lines, such as those that appear on the upper left petal. A touch of cadmium yellow is added to the pale yellow areas.

Fig. 4. Additional channeling and intense accents are added to define the petals. It is very important to soften the hard lines of the channeling with a clear brush.

The finished painting, reproduced actual size, appears on page 107.

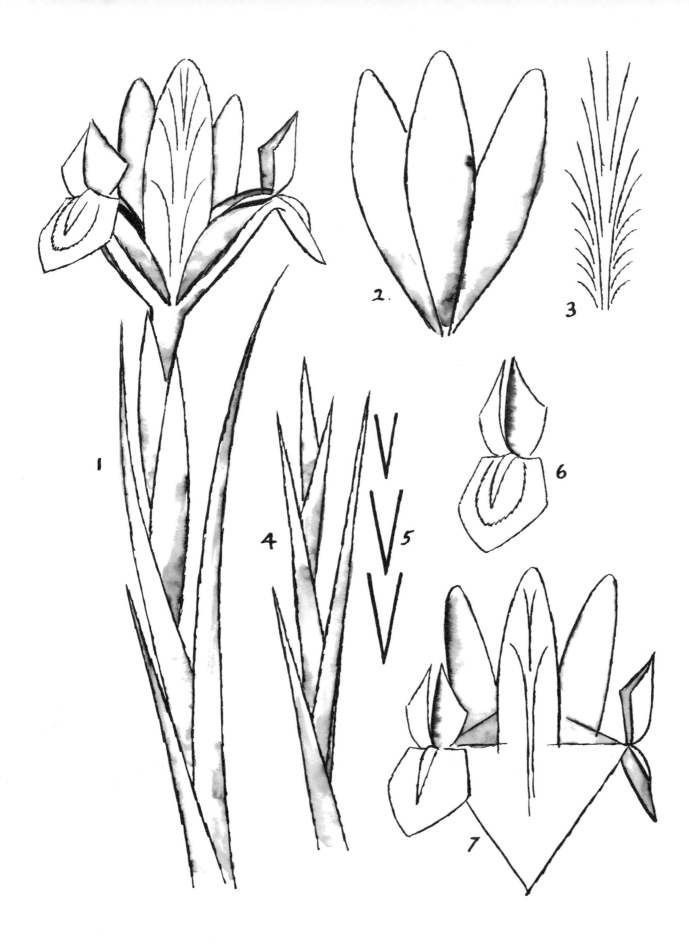

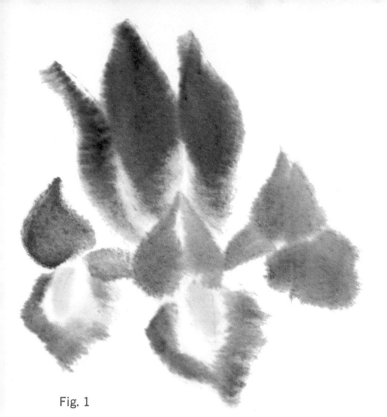

Fig. 1

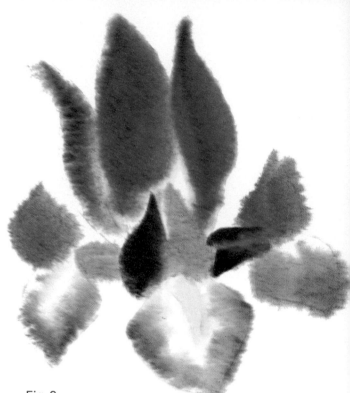

Fig. 2

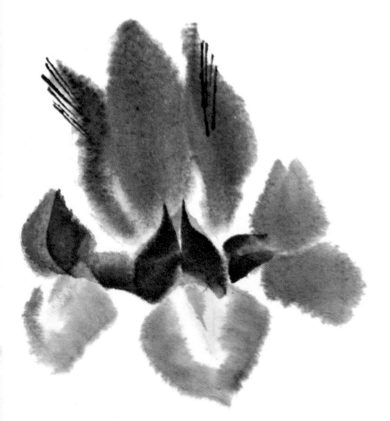

Fig. 3

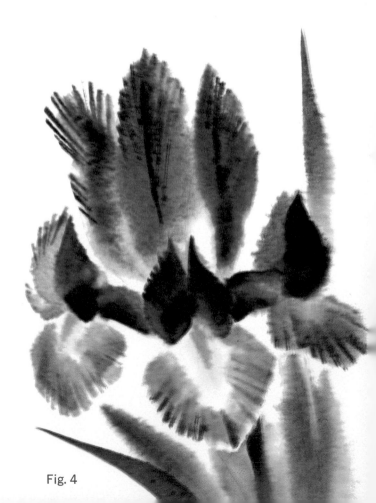

Fig. 4

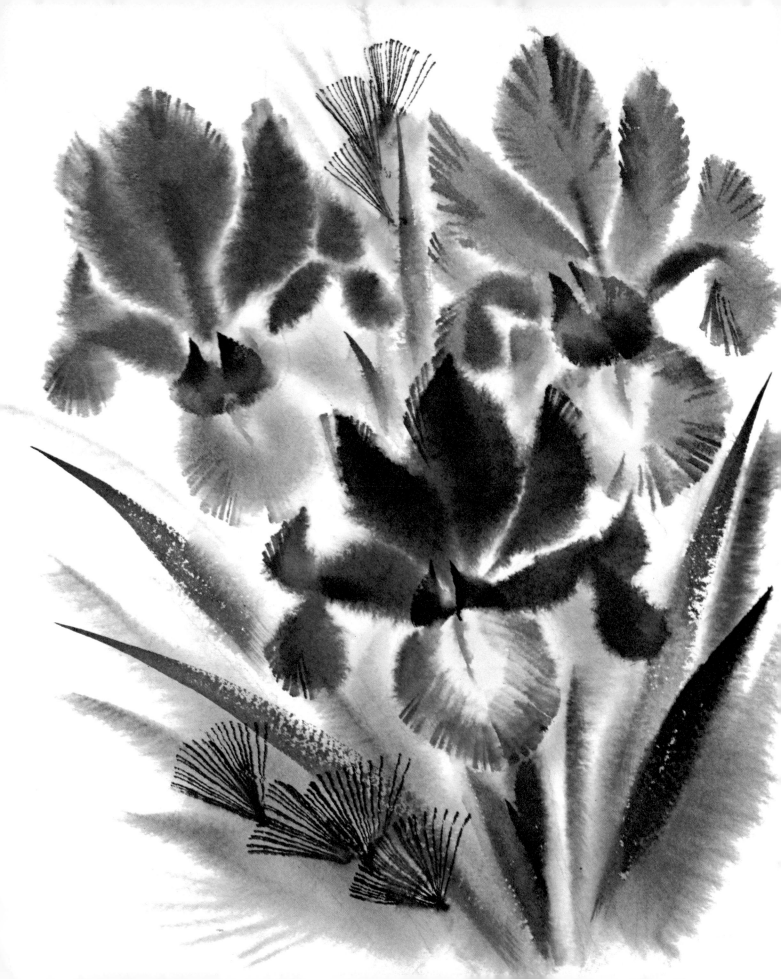

GLADIOLA

The gladiola is one of the easiest and most successful flowers to paint. The reason seems to lie in the structure of the flower. The petals suggest two triangles superimposed. Think of these triangles (Fig. 1) as a table top, and of the funnel or hollow cone (Fig. 2) as its only leg. Now cut a round hole in the table top in order to see the inside of the cone. This funnel will serve as a receptacle for the stamen (Fig. 3). The buds (Figs. 4 and 5) should be painted in a good zig-zag order, making sure that the point of each bud is well away from the stalk. In adding the blades, strive for variety in the direction of their growth, making one straight and the other twist like a ribbon. Use the THREE O'CLOCK AND RETURN to achieve this (Fig. 6). The one thing that really distinguishes the gladiola is the addition of the dark area suggesting the pit of the funnel. Now, with a clear brush, after wiping out all the excess water between your fingers so that the brush has a knife-like edge, describe the stamen by picking up pigment from the dark area and wiping outward with the brush, just as if you were making an incision.

Notes on Demonstrations:

Page 110.

Fig. 1. The main color shapes are put in in wet and allowed to dry from ten to fifteen minutes.

Fig. 2. After the paper has dried enough to permit light rewetting in certain areas, the definitive strokes, here the "channeling," are added.

Fig. 3. Additional channeling is added, using a clear brush to soften the hard edges and blend the strokes into the rest of the flower.

Fig. 4. The funnel is put in as follows: Wet the area from the center upwards. With richer paint, put in the darker part, starting at the center and sweeping up into the damp area. Then, and this is very important, paint out the stamen. This is done with a clear brush from which all excess water has been squeezed and which has been shaped to a sharp chisel edge by the thumb and forefinger.

The finished painting on page 111, reproduced actual size, is painted on the reverse — smoother — side of D'Arches 300 lb. paper. Either side of such handmade paper can be used with excellent results.

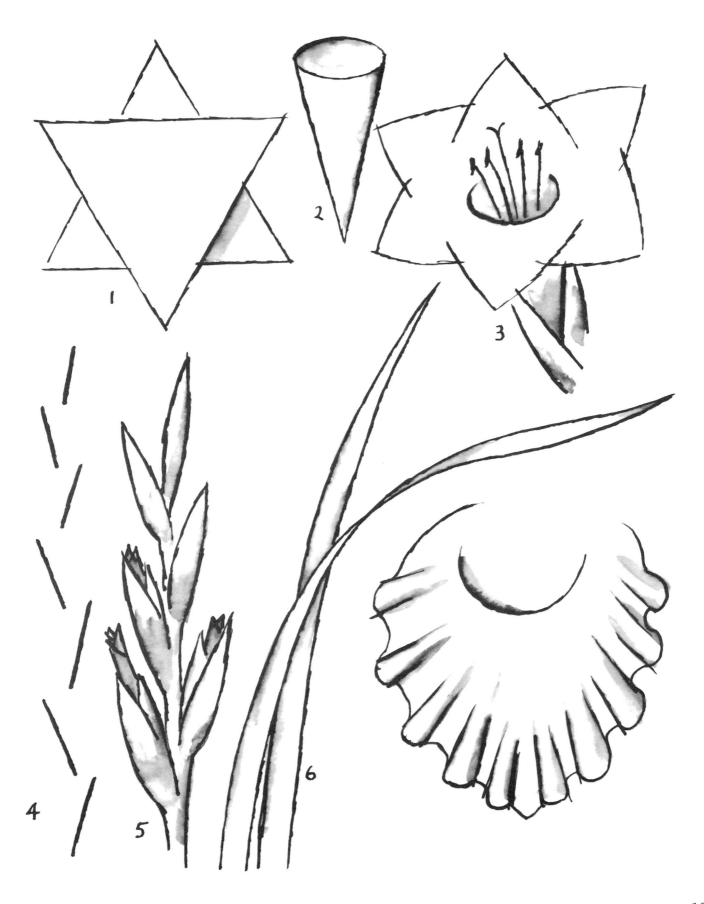

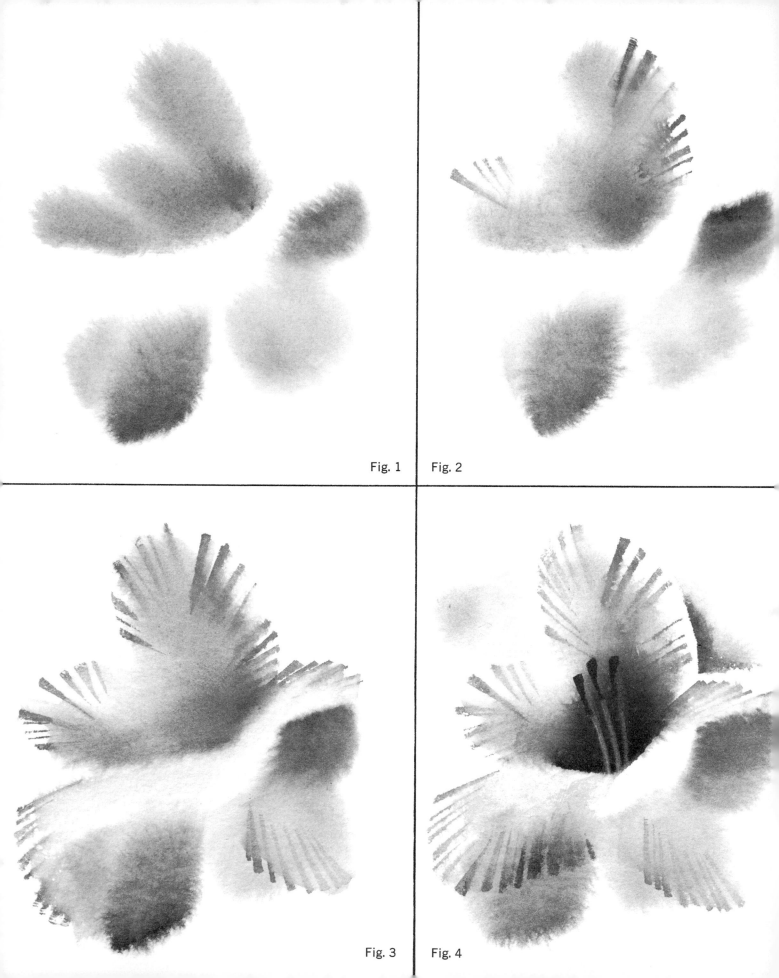

Fig. 1

Fig. 2

Fig. 3

Fig. 4

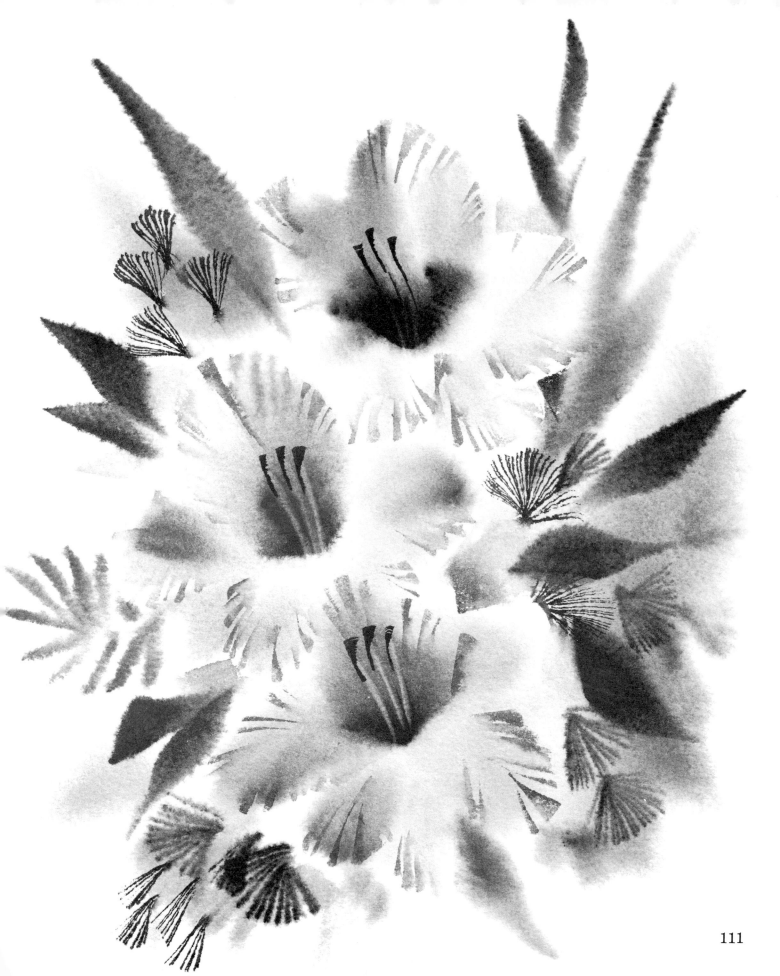

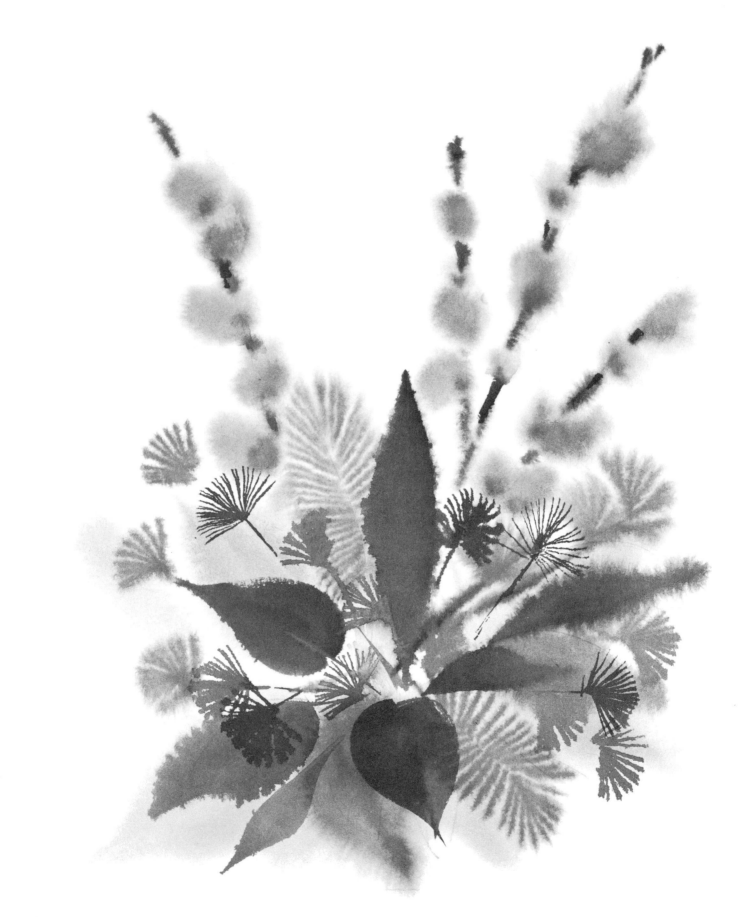

112

PUSSY WILLOW

Pussy willows are just as decorative in pictures as they are in flower arrangements. The most important thing to remember when painting them is to get the rich effect of furry little egg shapes. Practice in painting them can be both fun and instructive. The degree of wetness of the paper is very important. If the paper is too wet, we get the effect shown in Fig. 5 on page 114. If it's too dry it won't run at all. When working on a dry surface, we must be sure to wet well beyond the area that we intend to paint so that the paint won't catch up with the dry edge, as in Fig. 3. The colors I ordinarily use for pussy willows are burnt sienna and Payne's gray. These colors give rich, glowing warmth.

Demonstration:

Fig. 1

Fig. 1. Approximate tone to use for the lighter value of the pussy willow.

Fig. 2

Fig. 2. This is what happens when you don't wet a greater area than you intend to paint. The pigment catches up with the dry edge.

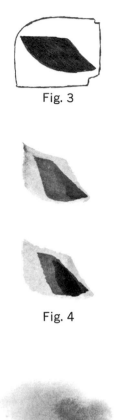

Fig. 3

Fig. 3. The stroke in relation to the wet area, indicated by the thin outline around the stroke.

Fig. 4

Fig. 4. Value of the next two tones that you need. The last one put in should be very dark.

Fig. 5

Fig. 5. The paper was too wet, and the definition and shape completely dissipated.

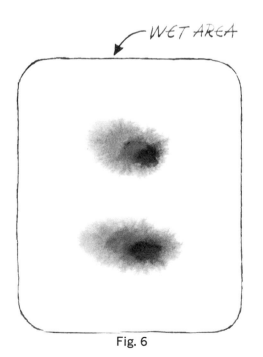

WET AREA

Fig. 6

Fig. 6. The proper distance that should be wet around the painted area. Working in wet, you would not have this problem, only the degree of wetness. Again, practice and patience are the only answer.

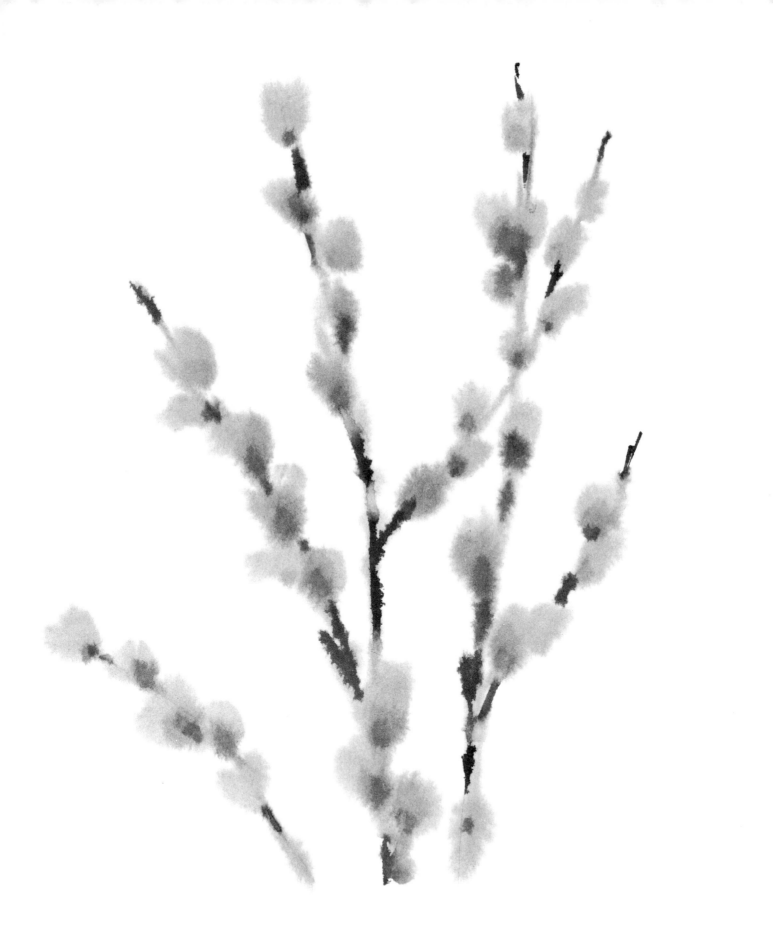

WHITE FLOWER

White flowers always seem to pose a special problem. In transparent watercolor the problem is solved by keeping as much of the white paper showing as possible, while still maintaining the identity of the flowers.

White flowers should be modeled with a minimum of tone. Too much tone tends to gray the blossom and kill the brilliance that is the whole spirit of a white flower. On the following three pages, I have illustrated this problem and its solution.

It will be interesting to look at the painting on the opposite page and try to find the error in the representation of that flower. The solution is on p. 118. For an explanation, see the diagrams with notes on p. 119.

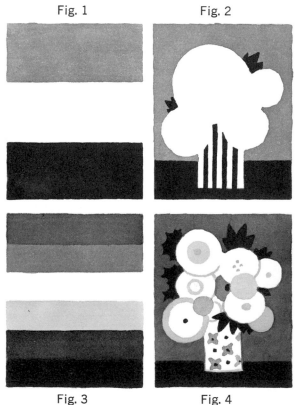

Fig. 1 Fig. 2

Fig. 3 Fig. 4

To make a successful painting, you should have at least three main values: white, gray, and black (Fig. 1).

You can make the white or black pattern the important one by increasing its proportions in relation to the other two. In Fig. 2, the white is made the important one by using gray as a foil and black as accent.

As a picture progresses, each one of the three values will, when divided, make additional values. In Fig. 3, we have divided each third in half, giving us additional range in value.

Fig. 4 shows the greater value range applied to a flower composition.

In a large and complex picture, each of the three primary values, white, gray and black, may be divided into many additional values.

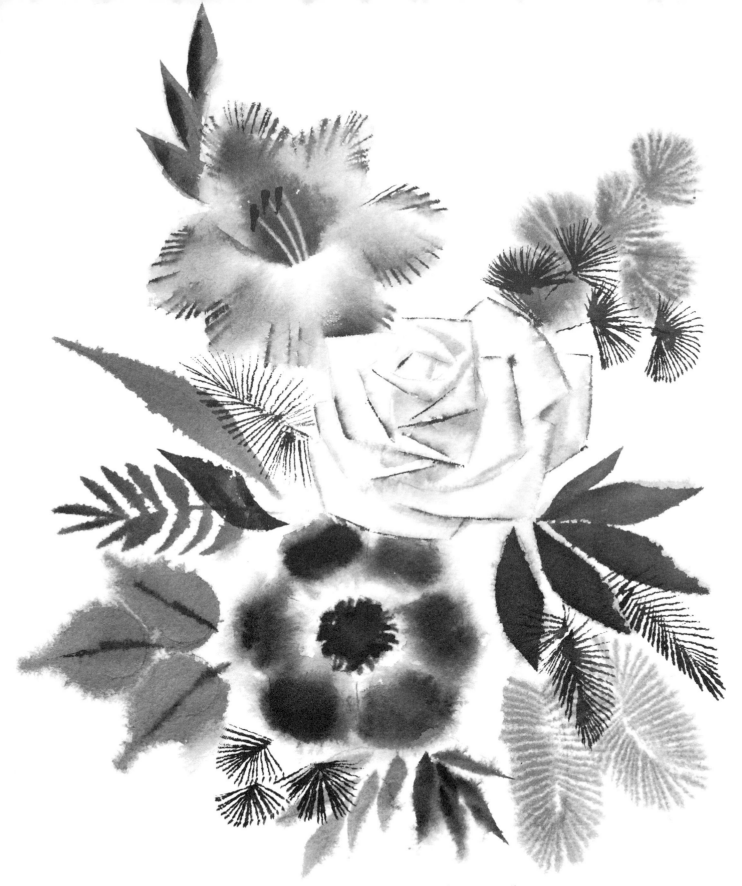

White flower weakened by too little contrast in surrounding area.

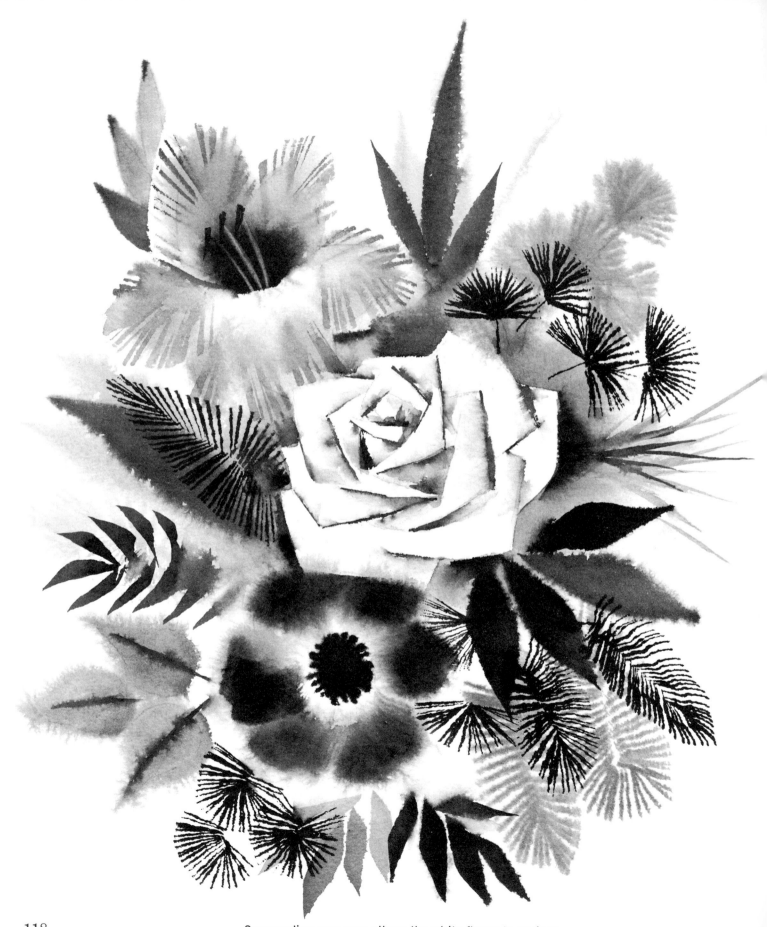

Surrounding gray area allows the white flower to project.

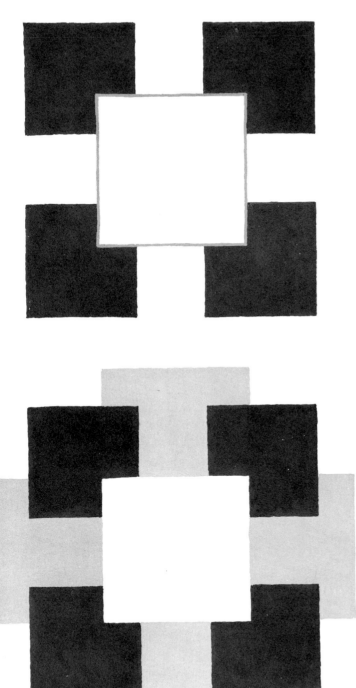

This illustration shows, in abstract form, the repeated error encountered in painting white flowers. Even with the thin gray line around it, the center square does not show up as white, just as the lines around the rose on page 117 do little to accentuate the white of that flower. Also, the black squares, which are equivalent to dark leaves or blooms, do not help to emphasize or project the square as a white pattern. Its power is dissipated into the white paper.

This illustration shows what took place on the opposite page. There is little doubt that the rose is a white rose just as in this diagram the white square projects its brilliance. By the simple addition of the gray squares, the white of the center square was contained and kept from spilling over into the surrounding white pattern. The equivalent in a painting of the gray squares would be leaves or a bit of background as shown on the opposite page.

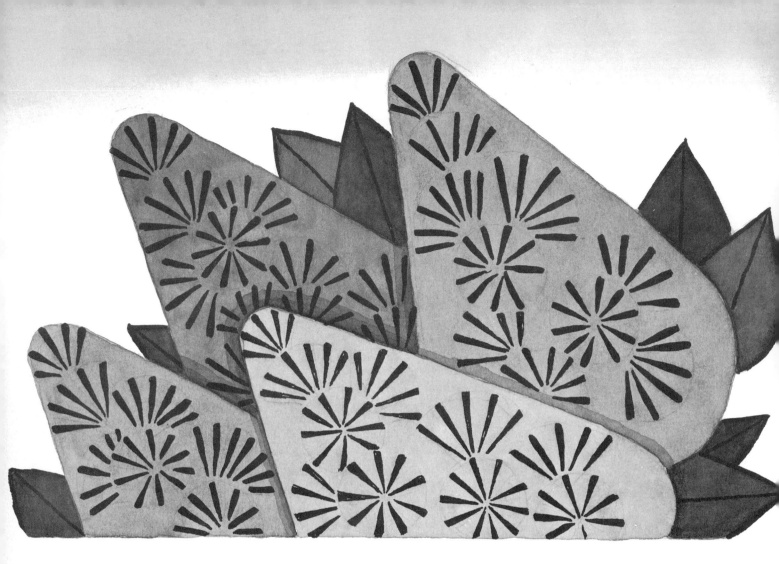

LILACS

Lilacs can present perplexing problems of rendering. You should try to convert them into a simple design. Instead of seeing all the little florets in the cluster, think of the cluster itself as one shape only, in this case a cone. Imagine a simple cone with a design painted on it. The next step is the design itself. Instead of trying to paint the florets as they are, a simple application of a technique stroke will suggest the flowers, provided they are arranged in the spirit of the lilac. It will give the effect of lilacs, at the same time creating a smarter looking rendering, rather than a ponderous, overworked, and "picky" floral.

In the diagram above, we show three clusters which are highly stylized for the purpose of emphasis. The finished painting of lilac clusters is on the opposite page.

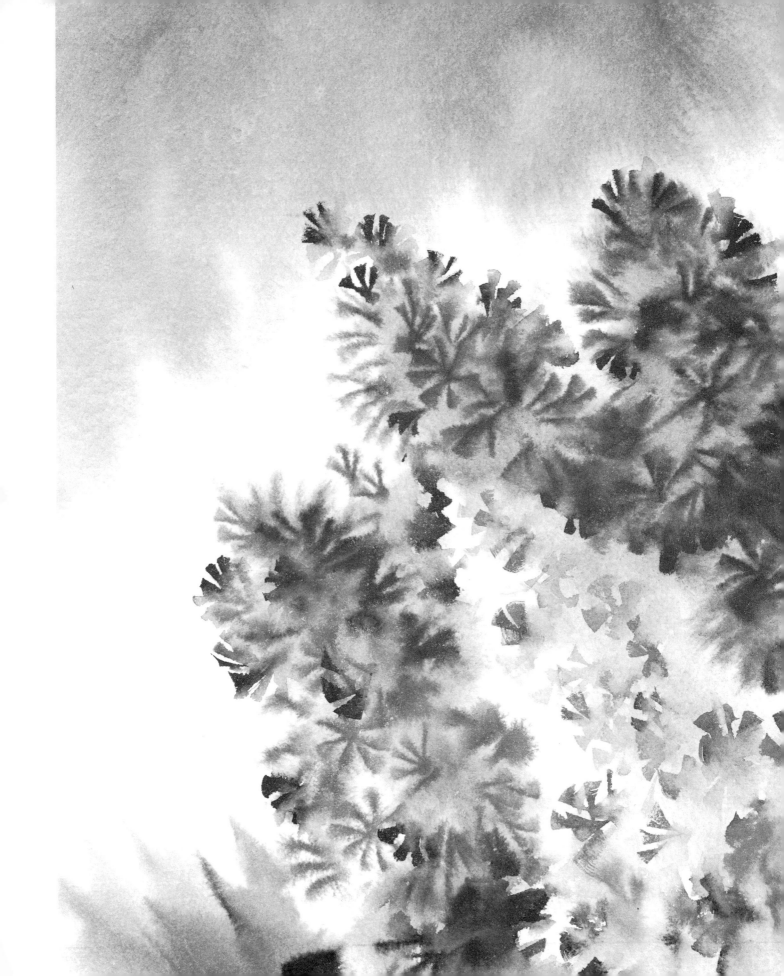

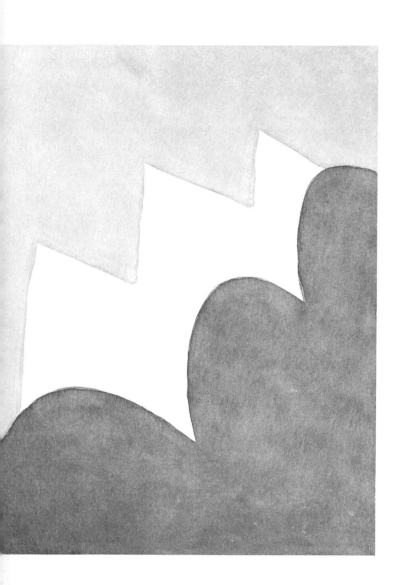

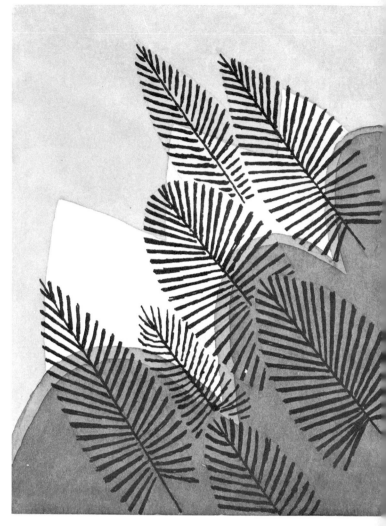

FERNS

Here, as everywhere else in this book, the emphasis is on total effect rather than literal representation. To paint ferns it is best to build the body of the plant by tonal background. The diagram on the left shows this approach in abstract terms. Using three values in the main background (light gray, white, and dark gray), we play the grill-like fronds of the ferns against them, as on the right. Keeping this approach in mind, the painting on the opposite page was made. It was executed in wet, and the dark streaks were put in as the paper dried, so that the weight and quality of line would vary.

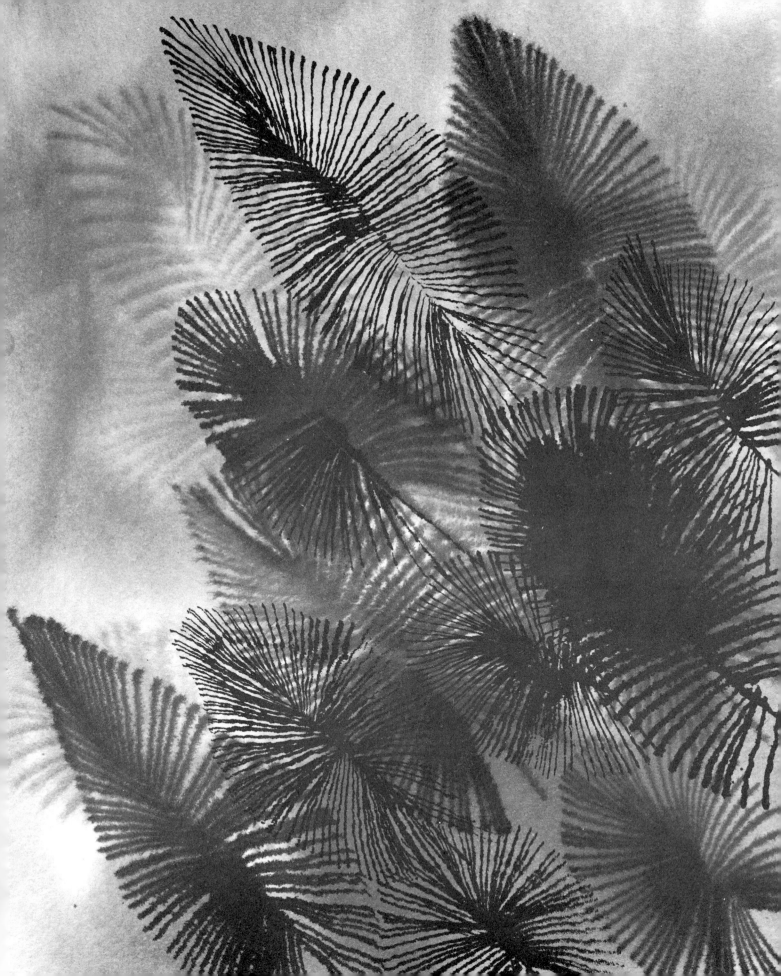

ANEMONES

Anemones are among the most decorative flowers. Their outstanding feature is a brilliance and depth of color matched by few other flowers. Their black centers, framed by the intensely colored petals, are like large eyes, fringed with heavy lashes. Some varieties have white rings around the "pupils," which add to their brilliance. The beginner should strive to get the full impact of the over-all color rather than the detailed shading of each separate petal. And remember, you must depend entirely upon the paper for areas that are pure white.

Fig. 1 shows the abstract design of the flower. In Fig. 2 it is made more recognizable. Figs. 3 and 4 show the application of the conical shape to the flower in different positions. Try to keep the geometric form in mind even when giving it an identity (see Figs. 5 and 6).

Notes on Color Plates:

Fig. 1. The main color areas are painted in wet.

Fig. 2. While the paper is still wet, deeper and more intense tones are added to the petals.

Fig. 3. After the painting has dried, the button is put in, first moistening well beyond the area around it.

Fig. 4. When the button is almost dry, the radiating accents are added. Be sure that your pigment is intense and soupy.

In the finished painting, page 127, reproduced actual size, note how the background helps to define the petals.

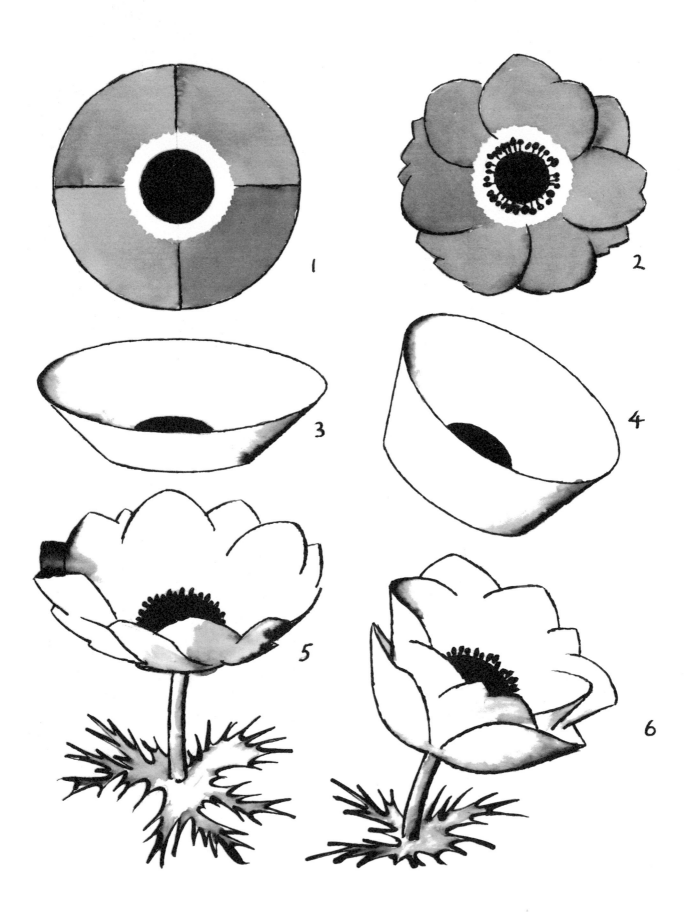

1

2

3

4

5

6

Fig. 1

Fig. 2

Fig. 3

Fig. 4

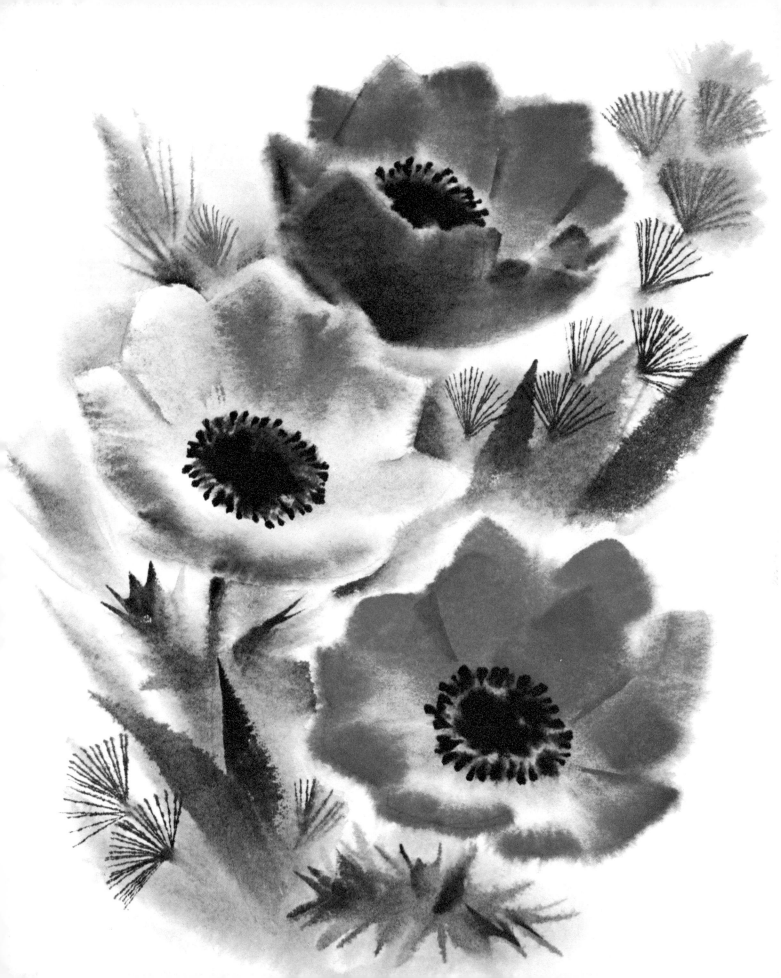

Problem

Painting a spray of white flowers can be taxing if you lose sight of the over-all design. The primary objective is to accept the fact that the flowers *must* remain white. Another problem is to achieve a strong abstract pattern in the white area that still looks like a spray of flowers.

Fig. 1, on the opposite page, shows a bouquet of white gladiolas. If we can forget the complex drawing of the flowers, we might conceive an abstract, white design like that in Fig. 2. The shadow that suggests the funnel in the center of the flower (see p. 108) has been conventionalized into just a dark design spotted on a white field. Fig. 3, page 130, shows a closer resemblance to the spirit of the flower. In the finished painting, Fig. 4, I have tried to keep as much of the abstract quality as possible.

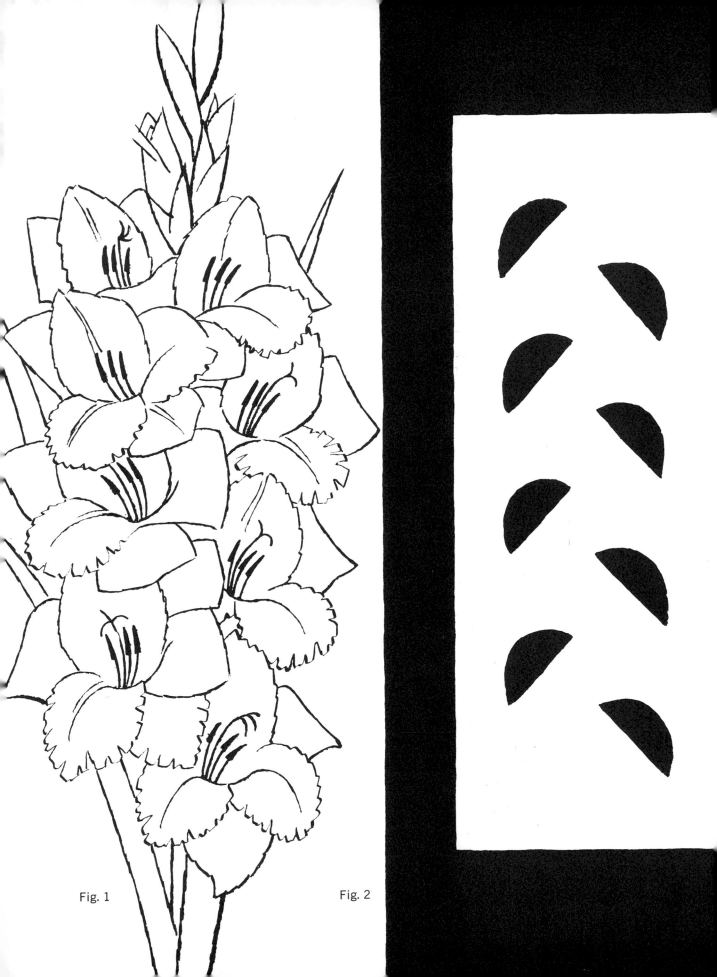

Fig. 1

Fig. 2

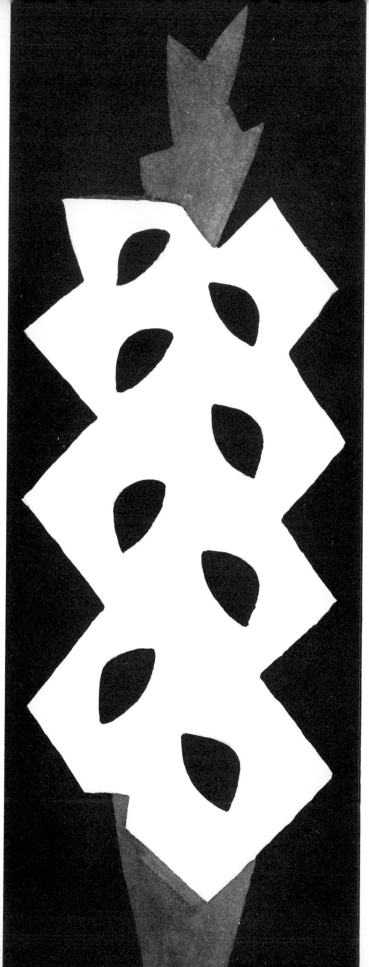

Fig. 3

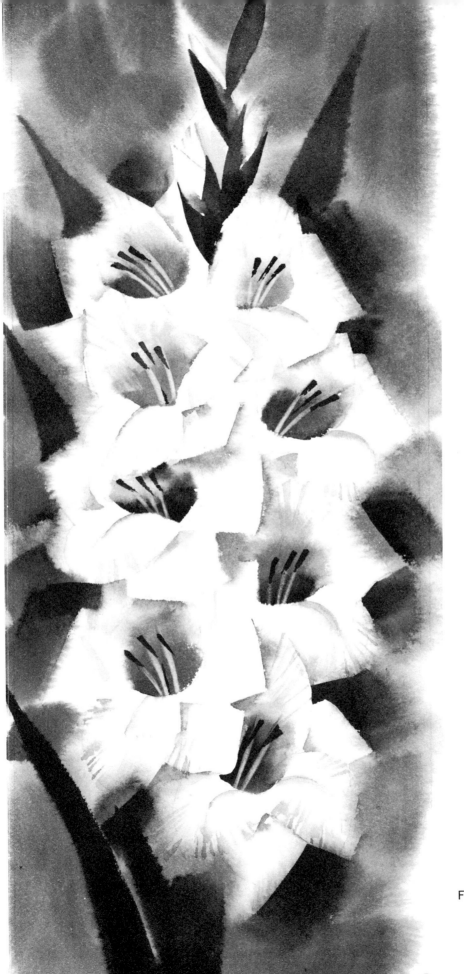

Fig. 4

Composition

A trainer of lions uses a chair when working with the big cats. The chair is not for physical protection, for a lion could turn it into matchwood with a single swipe of his paw. However, it does serve a definite purpose. When a chair is held by the back with the legs pointed toward the beast, he sees four different points of equal interest, and this confuses the animal. We as artists must do nothing to so confuse the observer. We should have only *one point*, one main visual idea in our painting. Composition is the arrange-ment of pictorial elements around a central idea. And this involves the division of picture space.

In Fig. 1 we have an equal division of black and white, which says not one thing but two, making it difficult to know where to concentrate. Fig. 2 shows a division of three equal parts. It is richer by the addition of the gray, but here too each equal division calls for the same attention.

In Fig. 3 I have again divided the rectangle into three divisions, but of different propor-

Fig. 1

Fig. 2

tions. There is no mistake now as to which is the prominent area. As an experiment of my own, I have based the divisions on the number three. The black is approximately three times the area of the white, and the gray, three times that of the black. This means we have nine parts of gray, three parts of black, and one part of white. This, I feel, is a pleasing division. It does not matter which color is in the larger or smaller division, as long as the ratio is nine-three-one. Obviously this ratio will not fit every subject. It is not intended to. But it gives an idea of the partitioning of space. In Fig. 4 I have taken the same proportions and changed the shapes so as to place a white square in a position overlapping the gray and the black. The proportions are still nine-three-one, but the effect makes the white square seem more brilliant. It looks whiter than the white of the rest of the page. If we look at this with an eye to abstract values, we can imagine the gray area as the volume of flowers, the white as the vase, and the black as the table.

Fig. 3

Fig. 4

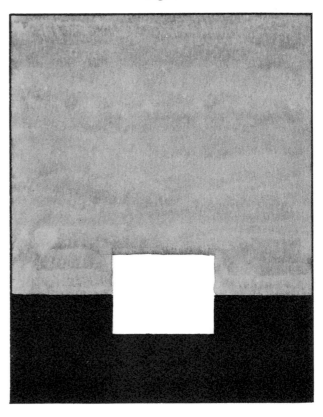

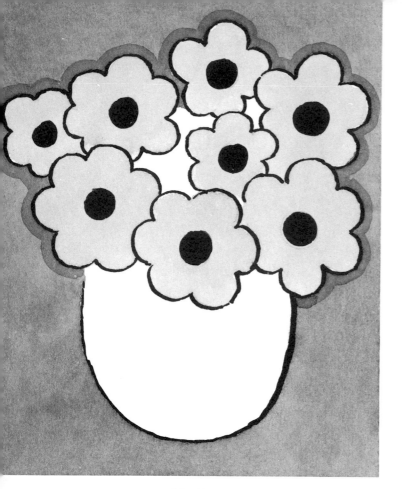

Fig. 5

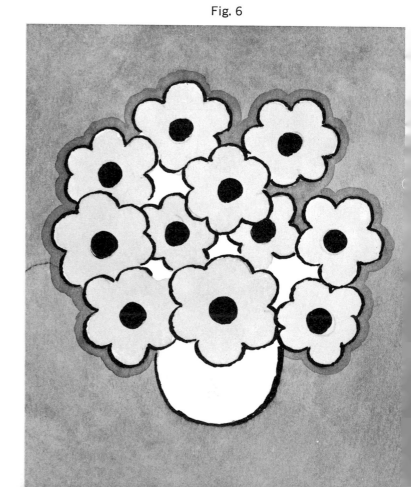

Fig. 6

134

Fig. 5 is a diagram of a vase of flowers. The division of space is too equal, resulting in too much emphasis on the vase. It is a good rule to keep the size of the vase small in relation to the flowers, which are, after all, the main subject. In Fig. 6 the vase and flowers seem the wrong size in relation to the picture surface. The background is almost equal in area to the vase and flowers.

Fig. 7 shows a more pleasing division of space. The flowers are definitely the important part of the picture. Fig. 8 shows a still greater simplification, which further emphasizes the flowers.

Fig. 7

Fig 8

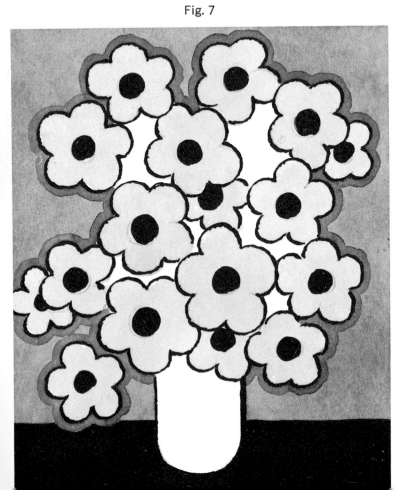

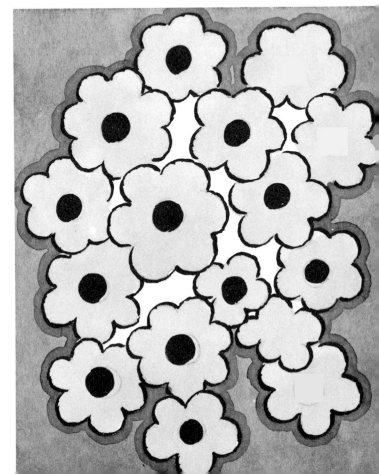

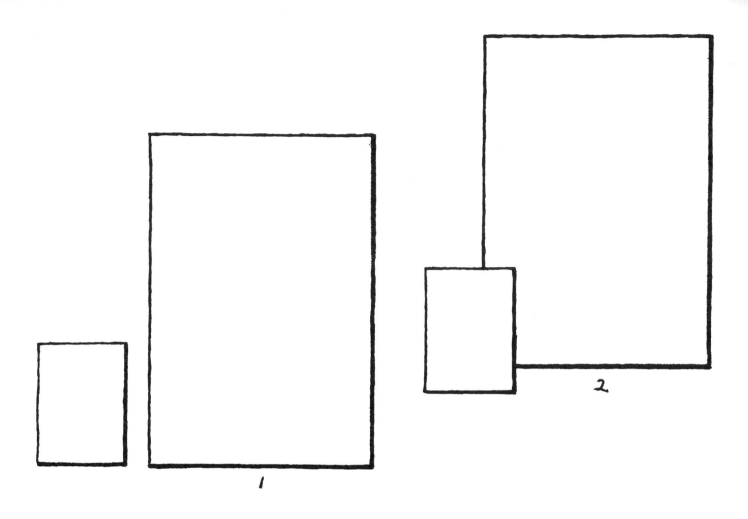

Perspective

In flower painting, we need a means to create the illusion of space and depth. For our purposes, it isn't necessary to explore the intricacies of vanishing points, but we must understand something of relative size and position of objects in space if we are to create naturalistic flower paintings.

For example, if we look at two railroad tracks that vanish on the horizon, and on them we place a locomotive in the distance and another quite close to us, we would notice, obviously, that the one farther away

appeared much smaller. Since they are both the same size, the significance lies in the fact that the closer one is in front of the other. But if we suppose that one of the engines is smaller than the other and that they are both at the same distance from us, the smaller one would *look* farther away.

Look at Fig. 1. If you were asked which rectangle looks closer to you, you would say the large one on the right. But look at Fig. 2. Because of its overlapping position, the small one now looks closer.

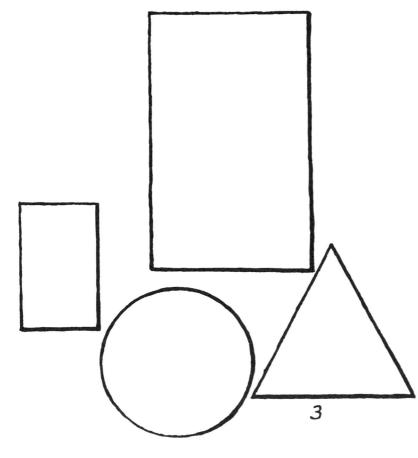

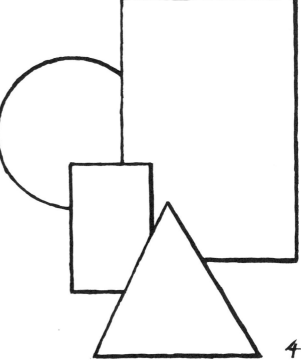

In Fig. 3 the four shapes are in an undetermined position with no identity in space. Fig. 4 shows an arrangement of the four objects overlapping, which immediately clarifies spacial positions and creates a feeling of a third dimension. This perspective device holds true for all objects, whether a glass in front of a jug or one flower in front of another.

Avoid having objects "kissing." This happens when two objects *almost* touch each other, confusing their mutual relationship in space.

Light against Dark—Dark against Light

There are two simple approaches to lighting: light against dark and dark against light. In the latter approach, the paper itself acts as the source of light, while the subject intercepts the light and the observer. The problem here is to block out the background light with the subject in such a way as to take advantage of the natural brilliancy of the paper and to create the impression that light is filtering through parts of the subject. This approach can create a very dramatic effect, as illustrated in the lower figure.

The upper figure illustrates the reverse principle. Here the background, either black or gray, acts as a foil for the white in the subject. Whereas in the lower figure the whites are in the background and are the source of light, in the upper figure the whites are in the foreground subject, the bouquet.

On p. 140 is a sketch of a vase of flowers placed against a source of light. In the sketch on p. 141 the whites are in the bouquet. The examples on pp. 142 and 143 show the dark against light, using the in-wet method.

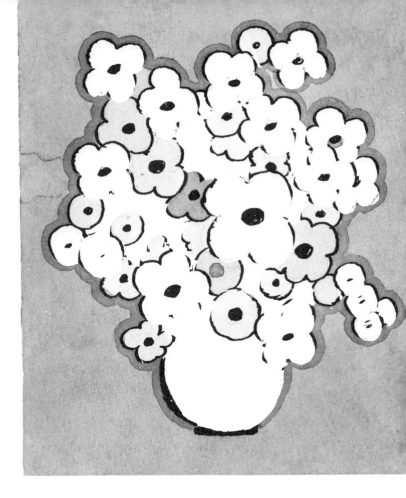

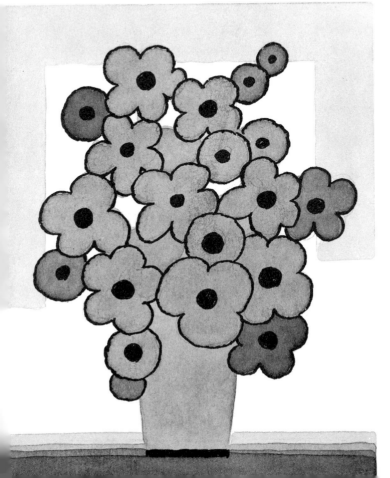

139

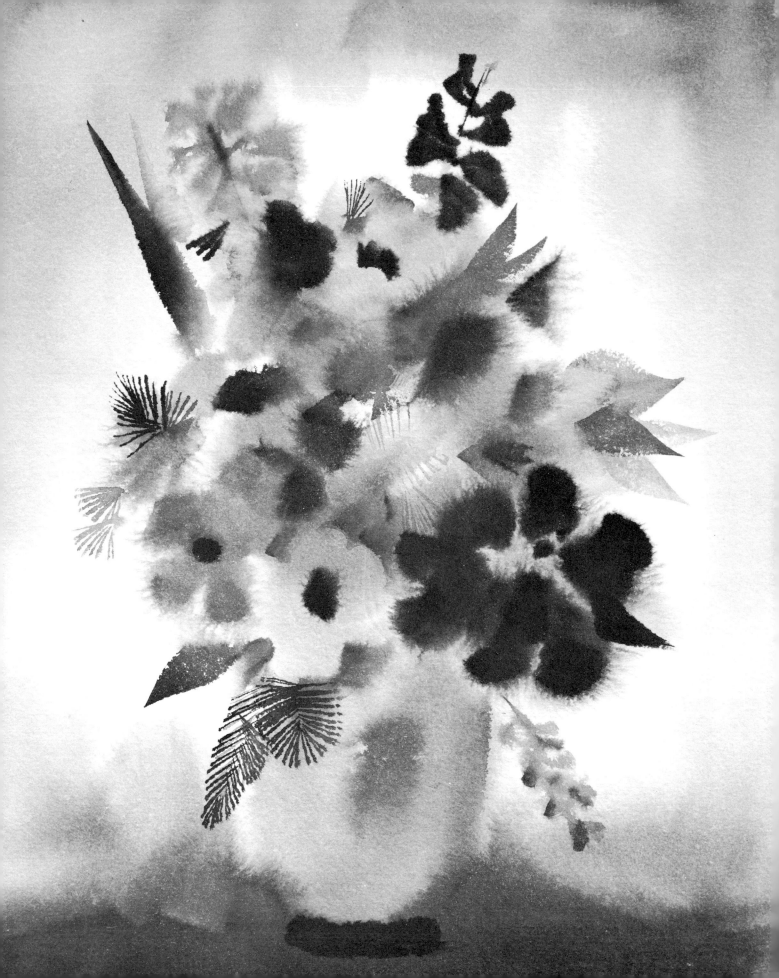

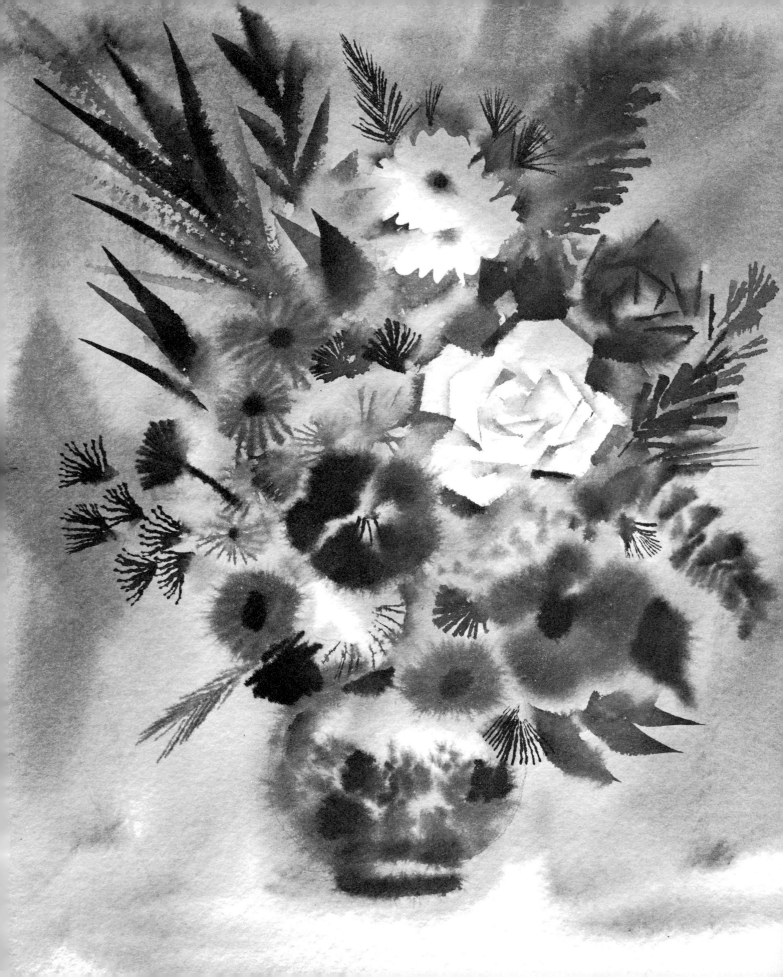

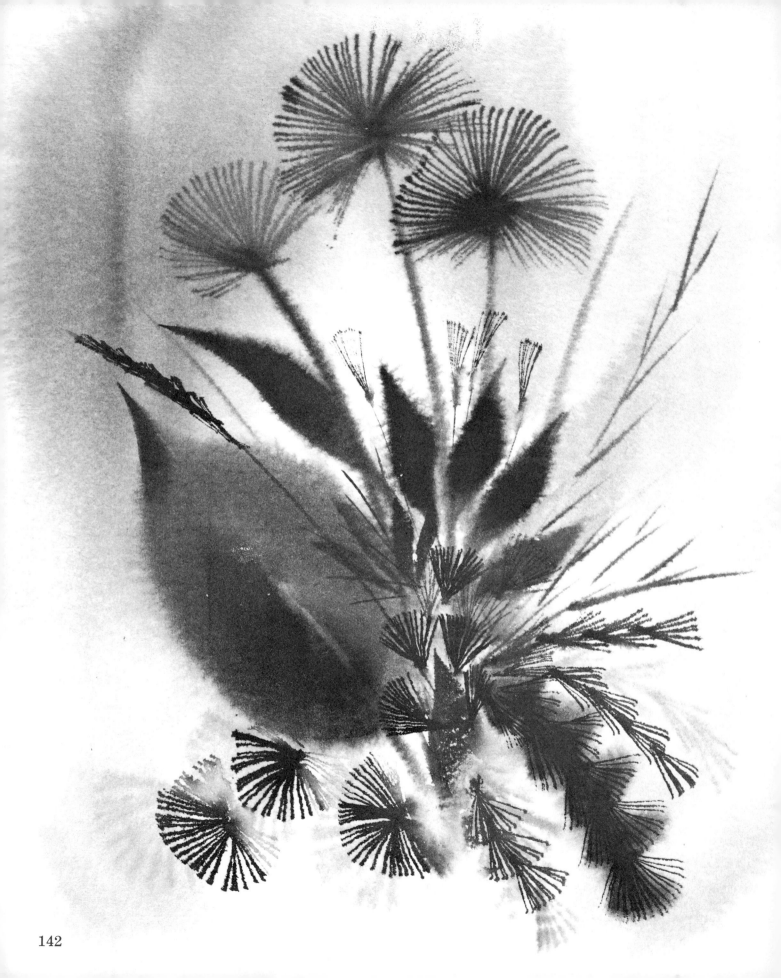

142

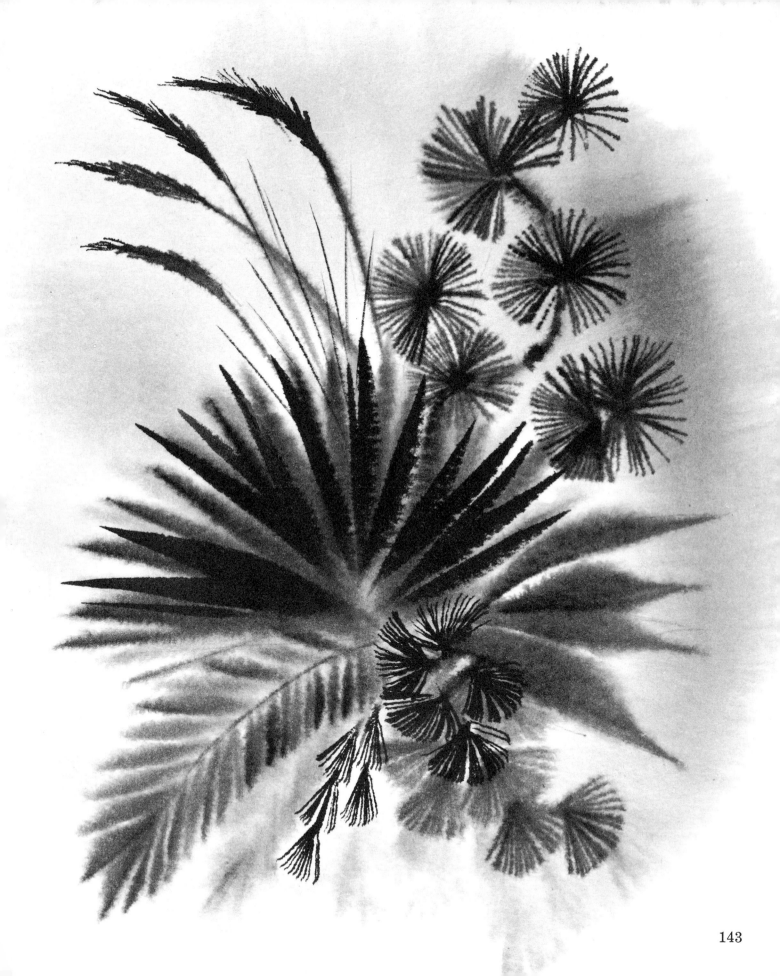